D1543776

**A REPORT TO THE FORD FOUNDATION**

# BLACK

# HISPANIC
# ART MUSEUMS

**A VIBRANT CULTURAL RESOURCE**

by Azade Ardali
with an introduction by
Mary Schmidt Campbell

FORD FOUNDATION
NEW YORK, N.Y.

One of a series of reports on activities supported
by the Ford Foundation. A complete list of
publications may be obtained from the
Ford Foundation, Office of Communications,
320 East 43 Street, New York, N.Y. 10017.

**Library of Congress Cataloging-in-Publication Data**

Ardali, Azade.
  Black and Hispanic art museums.

  1. Afro-Americans—Museums.   2. Hispanic Americans—Museums.
3. Art museums—United States.   I. Ford Foundation.
N6538.N5A73  1989   704'.0396073'07473   89-25975
ISBN 0-916584-40-2

478   December 1989
© 1989 Ford Foundation

# CONTENTS

# PREFACE

In 1986 the Foundation initiated a survey of black and Hispanic art museums.* The intent was to gather information on these institutions, assess their needs, and explore the possibility of launching a Foundation program to address those needs. The first stage of the survey was carried out by the Studio Museum in Harlem under the supervision of its then-executive director, Mary Schmidt Campbell, now Commissioner of New York City's Department of Cultural Affairs.

After canvassing the Expansion Arts Program of the National Endowment for the Arts, the New York State Council on the Arts, the African American Museums Association, and museum directors and professionals in the field, a preliminary list of sixty-five institutions was compiled. As the definition of the field was refined, the list was reduced to thirty-nine and finally to thirty. Consultants visited or conducted telephone interviews with the institutions and, in addition, a comprehensive survey questionnaire was sent to each.

On the basis of Dr. Campbell's report, the Foundation decided to pursue the study further. In 1988 Azade Ardali, management consultant to nonprofit, mainly arts, organizations, was engaged to review the institutions in greater depth, to establish a data base of the field, and to suggest programs that might address some of the institutions' needs. After compiling the information contained in the twenty-nine questionnaires that were returned, a second round of site visits was conducted to assess the collections and facilities and to interview staff and trustees.

The survey yielded a wealth of information, from sources of funding to staff size and composition, and from the condition of the museums' facilities and collections to annual attendance figures. The statistical data base, in conjunction with the information gathered in site visits, gives a sense of the current condition of black and Hispanic art museums.

The information in this report was obtained principally in 1988 and has been updated wherever possible. The field it surveys is volatile—new institutions come into existence, others disappear or merge, and leadership changes. Thus the report cannot claim complete accuracy as of the publication date.

The report begins with an overview of the field by Mary Schmidt Campbell. It is followed by Azade Ardali's statistical profile and a sampling of site-visit

*Also surveyed were several multidisciplinary museums with strong art components.

v

reports to round out the picture of the field. It concludes with recommendations to meet some of the museums' most pressing needs. Appendixes contain a copy of the survey questionnaire and a list of the institutions surveyed.

We hope that the report will alert public and private funders and policy makers to the major needs of these invaluable institutions. For its part, the Foundation has begun a major new initiative to assist America's leading black and Hispanic museums. In the first round of a three-year, $5 million program, seven museums were granted a total of $840,000 in 1989. The Foundation's commitment is an expression of its conviction that these museums are not only rich repositories of black and Hispanic art; they are also manifestations of the cultural diversity that enriches American life.

**Susan Berresford**
Vice-President, Program Division
Ford Foundation

# INTRODUCTION
## by Mary Schmidt Campbell

In the past twenty years, cities all over the United States have spawned a rich variety of black and Hispanic fine arts museums. A legacy of the civil rights movement, the earliest of these institutions were tangible responses to the call for ethnic pride and cultural self-definition during the socially and politically turbulent 1960s. The DuSable Museum in Chicago (1961), the Studio Museum in Harlem (1967), the Museum of the National Center of Afro-American Artists in Boston (1968), and El Museo del Barrio in New York City (1969) were launched more by enthusiasm and good intentions than by careful planning and capital development. Though housed at first in humble quarters—storefronts, converted lofts—in Roxbury, in Harlem, and on Chicago's South Side, their mandates were impressive. In the face of the almost total exclusion of black and Hispanic culture from the contemporary art scene, these institutions set out to exhibit, interpret, and, as they grew, to collect the artifacts of New World Hispanic culture and the African Diaspora. They also began to create a critical literature around these artifacts and to educate both their grass-roots constituents and the American public in general.

The museums' expansive mandates, however, were persistently threatened by their limited means. At the outset, they had neither permanent facilities nor endowments. Their collections were meager and their staffs were few in number and inexperienced. The funding for these fledgling institutions was often a fragile patchwork of public grants. Private support and earned income were virtually nonexistent.

What the museums did possess, however, was an extraordinary relationship with their respective communities. They brought a measure of cultural excellence to communities acutely bereft of cultural resources. The courses, classes, lectures, exhibitions, concerts, archives, and libraries of these "democratized" cultural institutions provided neighborhoods and families with opportunities for achievement and accomplishment. Examples of the resources offered include the DuSable Museum's library of 10,000 volumes, one of the most important resources of its kind in the Midwest, and the extensive research archives of the Museum of Modern Art of Latin America.

Perhaps the most important role these young museums came to play was an educational one. Many provided professional training in specific arts disciplines and, in some cases, in the museum profession itself through internships and volunteer programs.

In addition to offering training, black and Hispanic museums became important sources of scholarship, research, and information for the general public on subjects not normally represented in more traditional institutions. For example, the Bronx Museum's exhibit "The Latin American Spirit: Art and Artists in the United States, 1920-1970," organized in 1988, was the first historical survey of its kind. Another example is the Studio Museum in Harlem's exhibition of the art of the Harlem Renaissance and a companion book published by Harry N. Abrams, which provides important new insight into American art of the 1920s. Such efforts have been models for a second generation of museums such as the California Afro-American Museum, which organized an exhibition of the image of the black musician in nineteenth- and twentieth-century American painting, or the Mexican Museum's Frieda Kahlo show,* which explores the imagery of an important but infrequently exhibited Mexican painter.

Black and Hispanic art museums have also become an invaluable resource on which urban public schools draw to strengthen curricula. Carefully planned arts programs, developed in close cooperation with teachers and administrators, encourage interest in African American and Hispanic cultural values and traditions. They provide an important source of cultural identity for the students and a bridge between the school and the surrounding community.

Yet another, subtler, function the museums carry out is as a means of cultural interchange. They have not only opened up the cultural arena to people previously shut out; they have also made available to the larger society the richness and variety of black and Hispanic cultural traditions. Indeed, audiences for these institutions are considerably more culturally mixed than at more traditional museums.

Despite their limited funds, the first generation of black and Hispanic fine arts museums were surprisingly influential. Evidence of their success was the extent to which they acquired community support, especially in the acquisition of permanent facilities and line-item status on city and state budgets. The Museum of the National Center of Afro-American Artists in Boston, El Museo del Barrio in New York, the Studio Museum in Harlem, the DuSable Museum of African American History in Chicago, and the Bronx Museum of the Arts fall into this category. Even more impressive is that the first-generation museums provided the impetus for a second generation, for example, the Afro-American Historical and Cultural Museum in Philadelphia, founded in 1976; the Museum of African-American Life and Culture in Dallas (1974); the California Afro-American Museum in Los Angeles (1979) and an array of Hispanic groups, including the Mexican Museum, in San Francisco (1975); the Cuban Museum of Arts and Culture in Miami (1975); and Fondo del Sol in Washington, D.C. (1973), to name just a few. In many respects, the second generation fared somewhat better than the first. The most notable improvement was in their facilities. The I.P. Stanback Museum/Planetarium in South Carolina, and the California

---

*The Frieda Kahlo show originated in Mexico City. The curator was Antonio Reinoso Rodriguez and the show was sponsored by the Frieda Kahlo/Diego Trust.

2

and Philadelphia museums are among those for which a new facility was designed and built expressly for their purposes. Support for such facilities came not only in the form of stronger and more effective boards of trustees, but also, increasingly, from municipal, state, or regional political backing for these institutions.

Several second-generation museums such as the California Afro-American and the Philadelphia Afro-American were inaugurated with line-item status on either city or state budgets. No doubt the increase in black and Hispanic political power in the form of elected officials—particularly black and Hispanic mayors in Los Angeles, Denver, Chicago, Philadelphia, and Miami as well as state and federal legislators eager to address the interests of black and Hispanic communities—has helped these institutions. So, too, has the rapidly changing demographics of American inner cities.

Miami is a striking case in point. In 1960 Hispanics represented about 5 percent of the city's total. By 1985 they represented over 40 percent and by the year 2000 the number of Hispanics is expected to swell to 75 percent of the general population. The emergence in 1975 of the Cuban Museum of Arts and Culture in Miami, a modest though well-supported institution, is an excellent example of the community origins of Hispanic fine arts museums. Similarly, the vast majority of the black museums were established in such cities as Boston, Chicago, Los Angeles, New York, Dallas, and Philadelphia, all of which have substantial black populations and rich histories of black cultural and political organizations.

Although the free-standing black or Hispanic museum is a new urban phenomenon, it is not without precedents. Tucked away on the campuses of many Southern historically black colleges are some excellent art galleries. Fisk University in Nashville, Atlanta University, Morgan State College in Baltimore, Howard University in Washington, D.C., and Hampton University in Hampton, Va., to name a few, have impressive collections of African, Native American, American, and African American art. Founded after the Civil War, these historically black colleges were dedicated to advancing the education and citizenship of newly freed slaves. The primary goal of their art collections was to serve the educational needs of their art departments and art history curricula. Contact with the larger public and issues of cultural self-realization, though not overlooked, were not of primary concern. What did become a major concern, however, was collecting art created by black Americans. Today, the permanent collections of many black colleges contain masterpieces of black American painting and sculpture dating from the nineteenth century to the present. It should not be surprising, given the strength of this 100-year-old university museum tradition, that contemporary urban black museums have established a professional organization, the African American Museums Association. Its membership includes historical as well as art museums.

Hispanic museums, on the other hand, are not represented by a formal museum association, nor do they have as longstanding an institutional tradition as black colleges. They have, nonetheless, drawn inspiration from the cultural

communities of their countries of origin. Mexico, for example, provides an important precedent for both Hispanic and black institutions. In the 1920s Mexico assumed cultural leadership when the mural movement, spearheaded by the artists Jose Orozco, David Alfaro Siquieros, and Diego Rivera, became an expression of the democratic ideals of the Mexican revolution and a celebration of indigenous culture. During the U.S. civil rights movement of the 1960s—the era that gave birth to the contemporary urban museum—Mexico was often praised for its ability to organize and preserve the patrimony of its indigenous people, a reminder that political power is often linked to cultural proprietorship.

Puerto Rico has a younger, but no less vital museum tradition. In the 1950s two museums were established: El Museo de Arte de Ponce, the island's major general art museum, created through private philanthropy, and El Instituto de Cultura Puertorriquena, established by the Puerto Rican government to preserve the artistic and cultural patrimony of the people of Puerto Rico. The University of Puerto Rico also maintains an excellent art museum, founded in 1951, and there are frequent exchanges between Puerto Rican art museums and those in the continental United States, such as El Museo del Barrio, the Bronx Museum of the Arts, the Caribbean Cultural Center, and the Museum of Contemporary Hispanic Art.

The future for black and Hispanic fine arts museums points to a more global involvement with African and Hispanic cultures all over the world. The Museum of Modern Art of Latin America in Washington, D.C., for example, has an ongoing exhibition program highlighting contemporary work from the entire spectrum of Latin American and Caribbean countries. Examples of the international reach of U.S. black and Hispanic museums include the recent exhibition of Ethiopian artifacts by Boston's National Center and an exhibition of the contemporary art of six or eight African countries that the Studio Museum in Harlem is planning for 1990. The increasing contact and collaboration with artists and museums in African, Caribbean, and Latin American countries will doubtless result in a deeper awareness of African and Latin cultures in the United States. By the same token, interest in the culture and traditions of U.S. blacks and Hispanics is growing abroad. The participation of black art museums from all over the United States in the Japanese exhibit "Art of Black America," the growing number of foreign tourists visiting black and Hispanic museums, and the increase in international tours for museums' exhibitions, all signal a global direction for the future.

The new globalism is emerging even as the museums are strengthening their ties to local and regional communities. If the conclusions of the Commission for New York in the Year 2000 accurately forecast the future of cities throughout the country, the need for a community of healthy black and Hispanic art museums will only become more urgent. As the commission has indicated, the inner core of cities like New York will continue to be populated predominantly by blacks and Hispanics. These neighborhoods have long been plagued by unemployment, poor housing, and, most pertinent to this study, severely inadequate

educational resources. At the very least, the educational services provided by black and Hispanic fine arts museums will continue to supplement the resources of the schools and provide an important focal point for families. Also, although there are very real economic constraints in the inner cities, there is, at the same time, a rapidly growing middle class that can be tapped for financial and civic support as the museums grow. There are, however, even more compelling reasons to sustain the health of these institutions.

Art is not a luxury. Indeed, at its best, art is the expression of the very deepest human needs and desires. To sustain the excellence of human expression by supporting the programs of black and Hispanic art museums is to give voice to the most authentic visions of those communities. More importantly, these institutions give shape and direction to the values and traditions of black and Hispanic communities. The very fact that many of these museums have survived two decades without the array of financial resources available to more traditional organizations is proof of the abiding faith the communities have in them. Through these museums, black and Hispanic communities, schools, and families have had the opportunity to reaffirm the intrinsic worth and value of their culture, which they often see derided in the mass media or totally excluded from traditional museums. Without a fundamentally secure feeling of cultural self-worth, full participation in American democracy will remain elusive for black and Hispanic people. The trend toward marginalization cited by the Commission for New York in the Year 2000 is very real and very dangerous. Also very real, nonetheless, is the ability of blacks and Hispanics to build on their talents and community resources. The challenge for the future will be to find ways to mobilize these resources as efficiently and creatively as possible.

# STATISTICAL PROFILE

## 1. ETHNIC DESCRIPTION OF INSTITUTIONS SURVEYED

|  | Number | Percentage |
|---|---|---|
| Black | 17 | 59 |
| Hispanic | 10 | 34 |
| Black/Hispanic | 2 | 7 |

A majority of the twenty-nine institutions surveyed, nearly 60 percent, are black; one-third are Hispanic. Two, the Bronx Museum of the Arts and the Caribbean Cultural Center, direct their programming to both communities. Although the Hispanic institutions are few in number, they represent a much greater diversity than the black museums, reflecting the considerable diversity of Hispanic people in the United States. There appears to be little interaction among the Hispanic institutions, and there is no organized body like the African American Museums Association to facilitate networking.[1]

## 2. GENERIC DESCRIPTION OF INSTITUTIONS SURVEYED

|  | Art | Art/Culture/History | Other |
|---|---|---|---|
| Black | 9 | 7 | 1 |
| Hispanic | 7 | 1 | 2 |
| Black/Hispanic | 1 | 0 | 1 |
| Total | 17 | 8 | 4 |

Not all of the twenty-nine institutions are art museums. The ones that are not were included because they were thought to have significant arts components. Seventeen (59 percent) are art museums; eight (28 percent) are museums with a mandate encompassing art, culture, and history; three (10 percent) are multi-arts institutions; and one, previously affiliated with a library, is now a municipal museum. The second group contains a number of institutions still in the process of defining themselves and determining their exact focus. Others, however, intend to remain multidisciplinary institutions, taking the opportunity —as suggested by Samella Lewis, founder of the Museum of African Art—to "join history, culture, and esthetics in order to present art in context."[2]

A significant factor revealed in the above data is that while 70 percent (seven) of the Hispanic groups are art museums, only 53 percent (nine) of the black

institutions fall into this category, and 41 percent (seven) are historical or multidisciplinary museums. One possible reason for this, according to Jacqueline Trescott in an article in *American Visions*, is that "the tendency among black Americans is to define a museum as broadly as possible."[3] Trescott notes that the issue of what a black museum is has yet to be settled in the black community.[4]

Amina Dickerson, the former president of the DuSable Museum of African American History in Chicago, says, "At the time of their creation, many African-American museums felt compelled to examine the full picture of black history—locally, nationally, and internationally."[5] Dickerson says that mission statements were "purposely general and philosophical in nature,"[6] but that many museums later redefined these statements, sharpening their focus and clearly identifying the priorities of the museums.[7]

## 3. GEOGRAPHIC DISTRIBUTION

| | Black | Hispanic | Black/Hispanic | Total |
|---|---|---|---|---|
| Northeast[8] | 5 | 4 | 2 | 11 |
| South | 5 | 1 | — | 6 |
| Southwest (Texas) | 2 | — | — | 2 |
| West Coast (California) | 3 | 2 | — | 5 |
| Midwest | 2 | 1 | — | 3 |
| Puerto Rico | — | 2 | — | 2 |

The highest concentration of institutions, both black and Hispanic, is in the Northeast, where 38 percent of the groups in the survey are located. Secondary concentrations are in the South (21 percent) and in California (17 percent). It is noteworthy that all five of the black museums in the South are affiliated with black colleges. There are very few black or Hispanic museums in the Midwest.

## 4. YEARS ESTABLISHED

| | Black | Hispanic | Black/Hispanic | Total |
|---|---|---|---|---|
| 5–10 years | 3 | 1 | 1 | 5 |
| 11–15 years | 3 | 4 | — | 7 |
| 16–20 years | 4 | 2 | 1 | 7 |
| 21–30 years | 3 | 1 | — | 4 |
| Over 30 years | 4 | 2 | — | 6 |

Nearly 80 percent of the institutions in the study were established within the last thirty years, with 61 percent of these founded in the 1960s and 1970s, decades that witnessed much cultural as well as political activity. Also, the bicen-

tennial in 1976 prompted the launching of many new cultural enterprises. Of the remaining six institutions, all of which were established more than thirty years ago, five are university museums.

It should be noted that the survey asked for "Year established _____." This is open-ended enough to allow a variety of answers: the year of incorporation; the year the organization received its charter; the year it opened to the public; the year it was informally organized by its governing body.

| 5. GOVERNANCE | Black | Hispanic | Black/Hispanic | Total |
|---|---|---|---|---|
| Independent | 6 | 7 | 2 | 15 |
| Federal | 1 | — | — | 1 |
| Municipal | 1 | — | — | 1 |
| State | 1 | — | — | 1 |
| University-affiliated | 6 | 1 | — | 7 |
| Foundation-affiliated | — | 1 | — | 1 |
| Other | 2 | 1 | — | 3 |

Fifteen of the groups (52 percent) are independent organizations. They include seven (70 percent) of the Hispanic institutions and six (35 percent) of the black groups. An equal number of black museums (six) operate under the aegis of universities, whereas only one Hispanic museum is affiliated with a university. Three (18 percent) of the black institutions are government entities. The fourteen museums (48 percent) that are not independent are not self-governing and therefore do not have independent boards of trustees. Naturally, the value placed on these museums by their governing organizations strongly affects the museums' ability to function effectively.

| 6. FACILITIES | Black | Hispanic | Black/Hispanic | Total |
|---|---|---|---|---|
| Owned | 12 | 3 | — | 15 |
| Leased | 3 | 4 | 1 | 8 |
| Rented | 1 | 3 | 1 | 5 |
| Other | 1 | — | — | 1 |

Over half the institutions (52 percent) own the facilities they occupy. Another 17 percent (five) lease their buildings from their respective municipal governments at $1 per year. Thus, 69 percent (twenty) of the institutions have permanent facilities, an important stabilizing factor for organizations that may otherwise be fragile. Fully 82 percent of the black institutions are free from concerns about shelter—twelve groups own their structures and two others lease

them from their municipalities. The category "other" refers to the unique circumstance of the Museum of African-American Art, which occupies donated space on the third floor of a department store in Los Angeles.

| | Black | Hispanic | Black/Hispanic | Total |
|---|---|---|---|---|
| Adequate climate control (galleries) | 9 | 4 | 1 | 14 |
| Adequate storage space | 3 | 1 | — | 4 |
| Adequate office space | 5 | 2 | 1 | 8 |
| Currently involved in expansion | 8 | 6 | 2 | 16 |

Fourteen, or 48 percent, of the institutions have adequate climate control in their exhibit spaces. Although the questionnaire did not ask about climate control in storage, site visits revealed that this was an overwhelming problem for the majority of museums. A new or upgraded heating, ventilation, and air conditioning system was cited as a high priority. Only eight (28 percent) of the groups surveyed stated that they had adequate office space for administrative functions and staff and just four (14 percent) said they had adequate storage rooms. Sixteen (55 percent) are currently involved in some degree of physical expansion and three others said expansion figures in their long-term plans. These plans range from adding a sculpture garden to building an entirely new museum.

### 7. OPERATING BUDGET SIZE[9]

| | Black | Hispanic | Black/Hispanic | Total |
|---|---|---|---|---|
| Under $100,000 | 7 | — | — | 7 |
| $100,000–$299,999 | 2 | 4 | — | 6 |
| $300,000–$599,999 | 3 | 4 | — | 7 |
| $600,000–$999,999 | 1 | 2 | 1 | 4 |
| Over $1,000,000 | 4 | — | 1 | 5 |

The institutions with the largest operating budgets are either government-affiliated or are recipients of sizable line items from either state or municipal governments. All are black museums with the exception of the Bronx Museum of the Arts, which has exhibitions reflecting both black and Hispanic art. In FY 88 the budgets of three additional institutions climbed above $1 million, increasing the groups in this category to eight, or 28 percent, of those surveyed. One, the Studio Museum in Harlem, is projected to have an operating budget in excess of $2 million. At the low end of the spectrum, five of the seven institutions with budgets under $100,000 are university museums. In fact, no university-affiliated museum has a budget that exceeds $300,000. In one case, discre-

10

tionary income from the university is no more than $3,500, which has to cover everything from conservation to exhibitions.

**8. SOURCES OF FUNDING (PERCENTAGES)**

|  | Average for All Museums | Black | Hispanic | Black/ Hispanic |
|---|---|---|---|---|
| Earned income | 13 | 13 | 14 | 7 |
| Corporate/Foundation | 16 | 14 | 18 | 24 |
| Private/Individual | 7 | 5 | 12 | 2 |
| Government | 51 | 57 | 39 | 67 |
| University/Other | 13 | 11 | 17 | — |

*Note:* Three university museums were unable to provide data on this question.

Although the table above is useful in assessing the broad picture, the averaging of data introduces a level of generality that blurs important distinctions. For instance, though earned income averages 13 percent of the funding profile of these groups, the range is from 0 to 46 percent, and eight (31 percent) of the organizations receive more than 15 percent of their revenue from earned sources (for example, admissions, sales, and memberships). In the case of corporate and foundation support, the range is from zero to 33 percent, with twelve (46 percent) of the groups getting 20 percent to 33 percent of their funding from this sector. Thus, for nearly half of these groups, corporate and foundation support is a significant factor. Individual contributions are the weakest element in the income profile, ranging from zero to 50 percent. Only six museums, four of which are Hispanic, receive 10 percent or more of their support from individuals. Government support, on the other hand, is clearly the key ingredient for the survival of almost all of these institutions with the exception of university museums. Although the range is between 2 percent and 100 percent, fifteen (58 percent) of the twenty-six groups receive 50 percent or more of their funding from government sources. In some cases, such as the Smithsonian's Anacostia Museum, 100 percent of the budget is from one source—the federal government—whereas in other cases, government support is from a patchwork of local, state, and federal sources.

Since three university museums did not provide information, there are only four institutions in the last category, "University/Other," including the Museum of Modern Art of Latin America, which receives 75 percent of its operating budget from the Organization of American States (OAS). The range for the four reporting institutions is from 52 percent to 98 percent.

The two most significant factors revealed by the above data are the low level of individual contributions and the high level of government support. Clearly, the reason for the latter is that the purposes and missions of most of these museums are also priorities of federal, state, and local governments. In fact, many were founded with government support and continue to receive large infusions

**11**

of government funds. The limited nature of individual funding, in great part, reflects the relatively fragile economic status of the black and Hispanic communities, and the lack of support for programs of outreach and fund raising within majority communities.

### 9. FUNDING SOURCES BY SIZE OF OPERATING BUDGET

| | Under $100,000 N=4 | $100,000–$299,999 N=6 | $300,000–$599,999 N=7 | $600,000–$999,999 N=4 | Over $1 Million N=5 |
|---|---|---|---|---|---|
| Earned Income | 2 | 9 | 16 | 22 | 15 |
| Corporate/ Foundation | 5 | 15 | 19 | 16 | 23 |
| Private/ Individual | 2 | 20 | 4 | 4 | 3 |
| Government | 66 | 31 | 50 | 58 | 59 |
| University/ Other | 25 | 25 | 11 | — | — |

Note: Three university museums did not supply data.

Column 1 (museums with budgets under $100,000) should be read with the understanding that the three university museums that did not report data are almost fully funded by their respective universities. Had they been included, the numbers indicating government support (66 percent) and university support (25 percent) would have been reversed. With this exception noted, it is clear that government support increases with the operating budgets of museums. It is also true that the largest institutions attract the highest level of corporate and foundation support. Another interesting finding is that groups with budgets in the $100,000 to $300,000 range have the most diversified income profiles. Four of these six museums are Hispanic.

### 10. OTHER FINANCIAL DATA

| | Black | Hispanic | Black/Hispanic | Total |
|---|---|---|---|---|
| Long-Term Debt | 1 | 3 | 1 | 5 |
| Endowment | 2 | 1 | — | 3 |
| Reserve Fund | 3 | 4 | — | 7 |

Note: One university museum chose not to answer these questions.

Five of the groups indicate that they have long-term debt, with three of the five noting that the debts were mortgages. Three reported having endowments and seven have reserve funds. Generally, however, the sums are not large enough to serve either as a strong revenue source or as a sufficient cash reserve fund.

| Grants | Black | Hispanic | Black/Hispanic | Total |
|---|---|---|---|---|
| Challenge Grant–National Endowment for the Arts | 3 | — | 1 | 4 |
| Challenge Grant–National Endowment for the Humanities | 2 | — | 1 | 3 |
| Advancement Grant–National Endowment for the Arts | 1 | 1 | — | 2 |
| Applied to Institute of Museum Services (IMS)* | 9 | 3 | 1 | 13 |
| Received IMS Grant* | 4 | 1 | — | 5 |

\* For general operating support.

Although many of these institutions have had considerable success with small, project-oriented grants from the federal government, specifically the National Endowment for the Arts (NEA), they have had far fewer awards for general operating support, institutional advancement, endowments, or capital projects. One reason may be that the federal application process tends to be complex, discouraging all but a few from applying. Only thirteen (less than half of the surveyed group) applied for support from the Institute of Museum Services (IMS) and five (39 percent) of these were awarded operating funds. Just one of the five, the Mexican Museum, is a Hispanic institution. The Studio Museum in Harlem is the only institution in the groups surveyed that has been consistently successful in attracting federal grants, having received Challenge Grants from both the NEA and the National Endowment for the Humanities (NEH), an Advancement Grant, and IMS operating grants.

## 11. PERSONNEL
Note: Two institutions chose not to provide data on questions A through E.

### A. Staff Size

| | |
|---|---|
| Part time | 62 |
| Full time | 277 |
| Total number of employees | 339 |

### B. Average Size and Breakdown of Staff by Type of Museum

| | Black | Hispanic | Black/Hispanic |
|---|---|---|---|
| Part time | 1 | 4 | 4 |
| Full time | 11 | 7 | 16 |
| Total number of employees | 12 | 11 | 20 |

An unusual finding, not shown on the tables above, relates to part-time staff. Seventeen, or 63 percent, of the twenty-seven institutions have part-time personnel. All of the Hispanic groups supplement their work force with part-time staff, but only six, or 38 percent, of the black institutions use part-timers.

| C. Number of Employees per Institution | | | | |
|---|---|---|---|---|
| | Black | Hispanic | Black/Hispanic | Total |
| Under 5 | 6 | 1 | — | 7 |
| 5–10 | 3 | 5 | 1 | 9 |
| 11–15 | 2 | 2 | — | 4 |
| 16–20 | 2 | — | — | 2 |
| Above 20 | 3 | 1 | 1 | 5 |

The above figures include both part-time and full-time staff. Nearly 60 percent (sixteen) of the institutions have fewer than ten employees. Six of the nine Hispanic organizations fall into this category. The range is between a low of two employees at the Morgan State University Gallery of Art to a high of forty-three at the Studio Museum in Harlem.

| D. Staff Size by Size of Operating Budget | | | | |
|---|---|---|---|---|
| Number of Employees | Under $100,000 | $100,000– $299,999 | $300,000– $599,999 | $600,000– $999,999 | Over $1 Million |
| Under 5 | 5 | 2 | — | — | — |
| 5–10 | 1 | 2 | 4 | 2 | — |
| 11–15 | — | 2 | 1 | — | 1 |
| 16–20 | — | — | 1 | 1 | — |
| Above 20 | — | — | — | 2 | 3 |

There is a direct correlation between an increase in staff size and a rising operating budget. The disparity in budget size for organizations with five to ten employees primarily reflects a heavy use of part-time personnel.

### E. Staff Size by Title

| Title | Full time | Part time | Total[10] |
|---|---|---|---|
| President | 1 | — | 1 |
| Director | 23 | — | 23 |
| Curator/Registrar | 28 | 4 | 32 |
| Assistant Curators | 12 | 1 | 13 |
| Development Director | 11 | — | 11 |
| Development Assistants | 6 | — | 6 |
| Education Director | 12 | 2 | 14 |
| Education Assistants | 9 | 2 | 11 |
| Exhibition Specialists | 11 | 4 | 15 |
| Membership | 8 | — | 8 |
| Legal Counsel | — | 1 | 1 |
| Conservators | 5 | 1 | 6 |
| Administration | 59 | 12 | 71 |
| Financial Director | 7 | 2 | 9 |
| Library Services | 5 | 3 | 8 |
| Editorial and Publishing | 3 | 1 | 4 |
| Security | 40 | 15 | 55 |
| Technicians | 9 | 4 | 13 |
| Maintenance | 28 | 10 | 38 |

As revealing as the figures above is the response to the question "If you had additional funds, what positions would you add to your staff?" The top four categories mentioned were development and marketing staff, educators, curators, and clerical personnel. There are fewer financial directors than development directors and only three organizations expressed the need for additional finance and accounting staff.

For the most part, both professional and support staffing is inadequate in these institutions. In addition, few are directed or staffed by museum professionals. Some directors are community leaders, others are administrators whose experience is in another field; a few are artists. The lack of either museological training or experience is frequently true of the rest of the staff as well. The director of one major institution in the survey, emphasizing the need for training of existing personnel, said that not a single member of her staff of twenty-four had previous museum experience.

## 12. COLLECTIONS

| | Mean | Median | Range |
|---|---|---|---|
| Paintings | 279 (23) | 125 | 3–1,200 |
| Sculpture | 64 (21) | 25 | 2–500 |
| Drawings | 311 (19) | 75 | 1–3,400 |
| Prints | 179 (20) | 70 | 4–720 |
| Photographs[11] | 16,716 (19) | 200 | 1–300,000 |
| Folk Art | 355 (13) | 65 | 1–3,500 |
| Archaeological[12] | NA (2) | NA | 10–15,000 |
| African | 430 (17) | 105 | 1–2,300 |
| Pre-Columbian | 205 (6) | 140 | 20–600 |
| American Indian[13] | NA (2) | NA | 10–1,600 |
| Textiles | 38 (11) | 10 | 1–250 |
| Costumes | 21 (3) | 10 | 2–50 |
| Murals | 3 (4) | 3 | 1–4 |
| Films | 21 (12) | 15 | 2–60 |
| Video | 31 (12) | 15 | 1–100 |
| Musical Instruments | 34 (7) | 8 | 4–200 |
| Decorative Arts | 62 (5) | 25 | 10–142 |
| Historical Items[14] | 1,029 (7) | 200 | 40–4,100 |
| Books | 1,592 (14) | 500 | 2–10,000 |
| Current Art Publications | 47 (7) | 30 | 5–130 |
| Other Collections[14] | 3,240 (7) | 1,000 | 5–10,000 |

*Note:* Five of the twenty-nine institutions surveyed are not collecting institutions, although some have an eclectic assortment of objects. One of the remaining twenty-four did not provide numerical information on its collections. Therefore, the above table applies to only twenty-three organizations.

All of the groups have some paintings and most also have sculpture, drawings, and prints—objects one associates immediately with art museums. The greatest volume of material, however, is in photographs, books, and archival miscellany listed under "historic items" and "other collections." Of the twenty-four institutions responding, sixteen stated that they had an archive, seventeen that they had a library, and thirteen indicated that they had both.

The quality and significance of collections are beyond the scope of statistical analysis. The value of the above table is that it gives a sense of the range of the material to be cared for—to be catalogued, researched, conserved, displayed, and published.

Museums, first and foremost, are repositories of objects. Their principal function is to collect, preserve, and interpret material culture. Many museums in the United States and abroad were founded around core collections. That is not the case with most of these institutions. In many instances, they were the manifestation of a heightened social and political consciousness by individuals seeking a means of expressing their community's creative energy. A cultural center, a multidisciplinary space, a *Kunsthalle* might have served as well and provided greater flexibility. But these groups chose to assume a museum function and to begin collecting, sometimes without a defined purpose or an articulated acquisitions policy. Some of the collections, therefore, exhibit a very eclectic

16

approach or have material of minor aesthetic or historical value or of little relevance to the current mission of the institution. On the other hand, there are approximately one dozen museums in the group surveyed that have good to excellent collections. Another three museums, established in recent years, have acquisitions policies in harmony with their stated missions and have begun to collect selectively.

## 13. ACCREDITATION

As noted, only one of the institutions in the survey has been accredited by the American Association of Museums (AAM). It is the Studio Museum in Harlem, which received accreditation in 1987. Of the others, eight reported that they had no plans to seek accreditation and two stated that, though it was a long-term goal, it was premature for them to start the process until other priorities had been met. Twelve others, however, have already taken advantage of the AAM's Museum Assessment Program (MAP). Although MAP is not a prerequisite for accreditation, many museums use it as a first step in that direction, since it is an excellent means of self-study and a good tool for institutional planning and development.

Accreditation is a difficult and lengthy process, requiring the commitment of senior staff as well as trustees. It also demands the commitment of time and money, scarce resources that could be used for other projects. Accreditation, however, is important. It indicates to the field, to the public, and to funding sources that the institution is a professional operation. As Jean Weber, a former chairman of the Accreditation Commission, has observed,

Accreditation... is a meeting between a museum that voluntarily enters the process and sets its own goals and an outside peer review team of on-site visitors and commissioners that offers a broad perspective and helps the museum to judge whether indeed it has met its goals.[15]

According to a survey conducted in 1987 by the AAM, accreditation is held by 63 percent of museums with annual operating budgets in excess of $500,000.[16] Eleven of the twenty-nine museums in the survey have operating budgets of $500,000 or higher, but, as noted, only one is accredited.

| 14. COLLECTIONS MANAGEMENT/ MAINTENANCE/CONSERVATION | Yes | No |
|---|---|---|
| Is collection inventoried? | 18 | 6 |
| Is collection accessioned? | 14 | 10 |
| Is collection catalogued? | 10 | 14 |

Note: Twenty-four of the institutions replied to the questions in this segment.

Three-quarters of the institutions with collections (eighteen) indicated that their holdings had been inventoried, indicating that they have a list of objects identified by number and by location. A smaller number, 58 percent, have accession records of their collections, and less than half, 42 percent, have catalogued their holdings. A complete documentation of collections is essential, not only to safeguard the art and artifacts but also to ensure that they may be used for research and programming. Because of inadequate documentation, many of these collections are currently inaccessible to scholars and the public.

|  | Manual | Computer | Both |
|---|---|---|---|
| Type of system(s) used for documentation | 15 | 2 | 4 |

The majority of the groups—63 percent—still use a manual card file to record information. Two use a computerized collections management system and four (17 percent) use a combination of manual and automated systems. For museums with large, important collections a well-designed computerized system would provide greater access for scholarly research.

|  | Yes | No |
|---|---|---|
| Is current structure adequate for collections management needs? | 8 | 16 |
| Is current staffing adequate for collections management needs? | 4 | 20 |

Only 33 percent (eight) of the organizations surveyed indicated that their existing structure was "suitable to the proper function of caring for [their] collections and providing public access." Only four, or 17 percent, said that their staffing was adequate for managing their collections properly. Thus, in most of these institutions both staffing and habitat—particularly storage space—are inadequate for proper collections management and maintenance.

|  | Yes | No |
|---|---|---|
| Has a conservation analysis been conducted? | 10 | 14 |
| Is there a relationship with a regional conservation laboratory? | 11 | 13 |

Fewer than half of the groups—42 percent—have had a conservation analysis of their collections. Since the data do not reveal how recently the analyses were

conducted, the majority of the museums are not sufficiently informed about the current physical condition of their collections. Forty-six percent of the organizations have a relationship with a regional conservation laboratory; it is likely that some may not be aware of the existence of these publicly funded resources. On the other hand, two of the museums have their own conservation laboratories and personnel. The Ponce Museum's conservation department, for example, serves as the regional conservation resource center for Puerto Rico.

|  | Yes | No |
| --- | --- | --- |
| Is there a published catalogue of the collections? | 4 | 20 |

Only one museum has published a catalogue of the bulk of its holdings. Another three have published selections from their holdings, such as works from a specific decade, the *oeuvre* of a single artist, or paintings from a Latin American country or region. The remaining twenty, or 83 percent, have never published catalogues representing their collections. In many cases, the material is important enough to warrant publication.

### 15. EXHIBITIONS

**How many exhibitions does the museum mount each year?**

|  | Black | Hispanic | Black/Hispanic |
| --- | --- | --- | --- |
| 1–2 | 1 | 2 | — |
| 4–5 | 8 | 2 | 1 |
| 6–7 | 5 | 1 | — |
| 9–12 | 2 | 2 | — |
| 15–16 | — | 3 | — |
| Over 16 | — | — | 1 |

*Note:* One museum did not respond to the questions in this segment.

All of the institutions in the survey have changing exhibitions. The mean and median number of exhibitions mounted is five. However, the scope and documentation vary widely. An exhibition may be anything from display cases in a hallway to the Ponce Museum's "Jose Campeche and His Time," a landmark exhibition that traveled to New York's Metropolitan Museum of Art. Documentation may be no more than identification labels or it may include a fully illustrated, bilingual scholarly publication, elaborate interpretive labels, and large panels with text, gallery guides, and curriculum packets. Few of the organizations have the capacity to publish extensive scholarly tomes, lacking both staff and adequate financial resources, but many put out brochures and some regularly publish simple catalogues that provide illustrations of a representative sample of the work on display.

**Has the museum a written exhibition policy?**

|  | Black | Hispanic | Black/Hispanic | Total |
|---|---|---|---|---|
| Yes | 6 | 4 | 1 | 11 |
| No | 10 | 6 | 1 | 17 |

Eleven, or 39 percent, stated that they had a written exhibition policy.

**Is the staff adequate for the type of exhibitions mounted?**

|  | Black | Hispanic | Black/Hispanic | Total |
|---|---|---|---|---|
| Yes | 4 | 1 | — | 5 |
| No | 12 | 9 | 2 | 23 |

The vast majority of the museums—twenty-three, or 82 percent—believe their staffing to be inadequate for this purpose. The five that responded in the affirmative to the question are either university or government museums or receive a high level of government support.

|  | Black | Hispanic | Black/Hispanic | Total |
|---|---|---|---|---|
| Organize exhibit for travel in U.S. | 12 | 9 | 2 | 23 |
| Organize exhibit for foreign travel | 5 | 6 | 1 | 12 |
| Organize exhibit of art of other countries | 7 | 8 | 2 | 17 |

In spite of a shortage of adequate staff to organize exhibitions, the museums seem able to carry on intensive programs that include traveling shows. According to the data, twenty-three (82 percent) of the institutions organize exhibitions for travel in the United States and twelve (43 percent) mount shows that subsequently travel to other countries. Seventeen (16 percent) also organize exhibitions representing the art of other nations.

## 16. EDUCATION PROGRAMS

| A.  Outreach | Black | Hispanic | Black/Hispanic |
|---|---|---|---|
| Public lectures | 16 | 8 | 2 |
| Symposia | 12 | 6 | 2 |
| Tours | 16 | 10 | 2 |
| Recorded tours | 2 | — | — |
| Workshops and classes | 11 | 7 | 2 |
| Teacher training materials | 8 | 5 | 2 |
| Slides | 8 | 8 | 2 |
| Publications | 12 | 7 | 2 |
| Artist information | 10 | 8 | 1 |
| Community outreach | 14 | 7 | 2 |
| Music | 11 | 9 | 1 |
| Dance | 8 | 6 | 1 |
| Theater | 9 | 5 | — |
| Film | 12 | 7 | 2 |
| Video | 7 | 7 | 2 |
| Performance art | 6 | 7 | 2 |
| Literature | 10 | 9 | 1 |

The survey reveals that almost all of the institutions provide an array of interpretive programs and public events. The frequency, scope, and substance of these programs, however, are not revealed by the data. When asked how they would improve their services if greater resources were available, the respondents indicated that they would establish or strengthen tour-guide or lecture programs; focus on curriculum development, teacher training, and the production of educational modules, slide shows and videos; design programs for adults, senior citizens, and families; and put greater emphasis on outreach.

| B.  Training | Black | Hispanic | Black/ Hispanic | Total |
|---|---|---|---|---|
| Artist-in-residence programs | 4 | 4 | 1 | 9 |
| Internships | 5 | 8 | 1 | 14 |
| Paid internships | 2 | 2 | — | 4 |

Artist-in-residence programs are to be found in one-third (nine) of the organizations, a relatively high number. Internships are available in half (fourteen) of the groups; 80 percent (eight) of the Hispanic museums have internships, but only 31 percent (five) of the black organizations do. Paid internships are infrequent, provided by only 14 percent (four) of the institutions.

| 17. ADMISSIONS | Black | Hispanic | Black/ Hispanic | Total |
|---|---|---|---|---|
| Charge admission | 6 | 1 | 1 | 8 |
| Suggested donation policy | — | 6 | 1 | 7 |
| Free admission | 11 | 3 | — | 14 |

Forty-eight percent (fourteen) of the museums surveyed have a free admission policy, without a suggested contribution. This is partly because of the community served and partly attributable to the fact that nearly half of the organizations are not self-governing but rather are either university museums or government entities. One university museum has an admissions charge; at $2.50, it is the highest in the survey. All that charge admission provide reduced rates for such categories as members, students, children, senior citizens, and groups. Overall, the fees are low, particularly compared to mainstream museums in large metropolitan areas.

| 18. AUDIENCE | | |
|---|---|---|
| A.   Attendance | Number | Percent |
| Under 10,000 | 7 | 28 |
| 10,001–25,000 | 7 | 28 |
| 25,001–50,000 | 6 | 24 |
| Over 50,000 | 5 | 20 |

Four of the institutions were unable to provide attendance figures. The others provided data for the previous year showing a range of from 1,000 to 175,000 annual visitors. The mean number of visits reported was 36,136 and the median 22,100. For many of the museums the data include attendance at openings, festivals, concerts, and other types of special events.

**B. Visitor Demographics (Percentages)**

| Age | Black | Hispanic | Black/Hispanic |
|---|---|---|---|
| 0–4 years | 4 | 2 | 1 |
| 5–12 years | 18 | 14 | 16 |
| 13–17 years | 14 | 13 | 13 |
| 18–24 years | 16 | 16 | 23 |
| 25–44 years | 24 | 28 | 27 |
| 45–64 years | 16 | 19 | 16 |
| 65 and over | 8 | 8 | 4 |

The above numbers reveal very little difference in attendance by age among the three groups. Approximately one-third of the visitors, between 29 percent and 36 percent, are seventeen years or under, but the data do not indicate what percentage constitutes school groups. The highest degree of attendance and participation is in the eighteen- to forty-four-year bracket. This group represents 40 percent to 50 percent of all visitors to the institutions surveyed.

**C. Visitor Geographic Profile (Percentages)**

| | Black | Hispanic | Black/Hispanic |
|---|---|---|---|
| Local | 60 | 53 | 41 |
| County | 12 | 7 | 22 |
| State | 8 | 10 | 19 |
| Regional | 8 | 14 | 9 |
| National | 8 | 9 | 6 |
| International | 4 | 7 | 3 |

Not surprisingly, the vast majority of the visitors—from 70 percent to 82 percent—are from the host state, county, and local areas. Local attendance, at 60 percent, is particularly high in the case of black museums; national and international visitation is highest, at 16 percent, for the Hispanic institutions.

**D. Visitor Ethnic Profile (Percentages)**

| | Black | Hispanic | Black/Hispanic |
|---|---|---|---|
| Black audiences | 71 | 14 | 35 |
| Hispanic audiences | 3 | 50 | 48 |
| White audiences | 21 | 31 | 12 |
| Other audiences | 5 | 5 | 5 |

23

There is very little overlap ethnically in the audiences of black and Hispanic museums, although more blacks seem to visit Hispanic museums than vice versa. The two institutions in the survey that serve both a black and a Hispanic constituency, on the other hand, reveal relatively equal representation, with a somewhat higher Hispanic presence. The non-minority audience represents about one-fifth of the attendance at black museums and approximately one-third of that at Hispanic organizations. The two museums in Puerto Rico provided no data on this question, stating that the distinction had no relevance in their communities.

## 19. MEMBERSHIP

|  | Black | Hispanic | Black/Hispanic |
|---|---|---|---|
| 100 and under | 2 | 2 | — |
| 101–500 | 2 | 5 | 2 |
| 501–1,000 | 2 | 1 | — |
| 1,001 and above | 4 | 1 | — |

Twenty-one of the twenty-nine museums have membership programs. Those with none are either government-affiliated or university museums. (Only one university museum offers memberships.) Of those with no membership program, all but one are black museums. The mean number of memberships is 820; the median is 450; and the range is 50 to 4,000. Nine out of the twenty-one groups, or 43 percent, have 500 or fewer members. When asked how memberships could be increased if funds were available, respondents cited direct mail campaigns, the purchase of membership-specific software, and the enhancement of membership benefits.

## 20. PUBLICATIONS

Many of the museums publish exhibition catalogues. A few also publish monographs in specific areas of research unrelated to exhibitions. Other publications include newsletters, calendars of events, educational materials for schools, general information, and membership brochures. Few publish annual reports on a regular basis.

### 21. PROMOTION

| | Black | Hispanic | Black/Hispanic |
|---|---|---|---|
| Local newspaper | 15 | 10 | 2 |
| Direct mail | 12 | 8 | 2 |
| Other newspapers | 13 | 8 | 2 |
| Paid radio/TV spots | 5 | 3 | 2 |
| Posters/flyers | 13 | 10 | 2 |
| Public service radio/TV spots | 15 | 10 | 2 |

*Note:* **One museum did not answer this question.**

All of the institutions use an array of promotional vehicles. The least utilized are those that are expensive—direct mail and paid radio and television advertisements. All of the Hispanic museums have bilingual messages. Two of the black museums occasionally use Spanish in their advertisements.

# NOTES

1. The African American Museums Association in FY 86-87 conducted a landmark survey of its membership (126 institutions, 350 individuals) and of other black organizations collecting or exhibiting objects relating to the black experience. Funded by the National Endowment for the Humanities, the survey, though important, is too broad in scope to have direct relevance to the present study.

2. Samella Lewis, "Beyond Traditional Boundaries: Collecting for Black Art Museums," *Museum News*, Vol. 60 (January/February 1982), p. 41.

3. Jacqueline Trescott, "Museums on the Move," *American Visions,* March/April 1986, p. 27.

4. *Ibid.*

5. Amina J. Dickerson, "African-American Museums: A Past Filled with Pride, A Future Filled with Challenges," *The Journal of Arts Management and Law,* Vol. 18, no. 2 (Summer 1988), pp. 41-42.

6. *Ibid.*

7. *Ibid.*

8. Includes Washington, D.C.

9. The data pertain to FY 87 with the exception of one institution that provided information for FY 86 and two others that submitted data for FY 88. Some of the figures were corroborated by checking financial statements, but, since half of the groups function under the aegis of an umbrella organization, there is no independent audit available for their operations.

10. "Mean" refers to the average number or value, "median" to the middle number in a series, and "range" to the difference between the largest and smallest values in a sample. Thus, in the category of sculpture twenty-one of the twenty-three organizations have at least one item, with the average or mean in each collection being sixty-four. The range signifies that the organization with the least number of sculptural items has two and the one with the most has 500. Finally, according to the median, ten of the twenty-one groups have fewer than twenty-five pieces of sculpture and ten have more than twenty-five.

11. The median is more representative of the field in this case, because there are two major collections that distort the mean: the 300,000-item Jack Franklin collection in Philadelphia, which provides a wealth of historical and social information on the city's black community during the middle of the twentieth century, and the 10,000-item Van Der Zee archives at the Studio Museum in Harlem. With the exception of the Van Der Zee material and a few small collections from other museums, most of the photographic

holdings have little aesthetic value and are significant primarily from a historical and social perspective.

12. The 15,000-item collection represents the holdings of the museums of the University of Puerto Rico at Rio Piedras.

13. This is Hampton University's extensive collection of American Indian (primarily Plains Indian) art and artifacts.

14. Archival material is the key element in these categories.

15. Jean Weber, "Accreditation and Small Museums," *Museum News*, December 1986, p. 16. For an alternate view of accreditation see Stephen Weil, "Questioning Some Premises," *Museum News*, June 1986, pp. 20-27.

16. Telephone discussion with Ron Lambert, American Association of Museums, September 1988.

# SELECTED SITE REPORTS

Following site visits to the survey participants in 1988, capsule overviews were written. They were assembled from a mosaic of material—the survey questionnaire, AAM Museum Assessment Program reports, applications to the Institute of Museum Services, descriptive brochures, annual reports, financial statements, and other documents submitted by the institution—and filtered through the data and impressions gathered from the interviews with directors, staff, and trustees. Eight of the capsule descriptions are provided here to give a sense of the range and diversity of black and Hispanic museums.

### Hampton University Museum (Hampton, Virginia)

Hampton University is located in southeastern Virginia, near Norfolk, on the shores of Chesapeake Bay. The museum is housed in a four-story brick and stucco structure, the Academy Building, which was designed by Richard Morris Hunt and constructed by Hampton students and faculty. Dedicated in 1881, the building is now a National Historic Landmark.

The museum was founded in 1868, the same year as the university. Until the 1920s it was the only museum in the South open to blacks. The collection was initiated as a teaching resource—teaching technical expertise and craft—to supplement Hampton's manual training and academic programs. It now has approximately 7,000 artifacts and is the foremost of the collections held by the historically black colleges.

The museum is governed by the university's board of trustees and has a loosely organized advisory council that meets on an ad hoc basis. Unlike the majority of university museums, it is independent of the fine arts department since it is viewed—and valued—as a university-wide resource. The director, who is a peer of the undergraduate and graduate school deans, reports to the vice-president of academic affairs and has frequent contact with the university's president.

The museum's budget fluctuates, based on the level of outside funding available in any given year. This support is, of course, project-driven and is dependent on the director's success with fund raising. Basic operating support, including core salaries, is provided by the university. In 1988 this amounted to $85,000 and represented 80 percent of total expenses for the year. The

museum's annual budget in the past five years has varied between $90,000 and $150,000. This does not include the considerable degree of support provided by the university in in-kind services and materials.

Hampton's holdings are astonishing in their breadth and quality. Most of the material was acquired by Hampton faculty and students, then either donated or sold to the school. There are six distinct collections. The first to be developed was the Oceanic collection; it was assembled by Hampton's founder and first president, who was born in Hawaii. The Oceanic collection now has over 800 objects and represents eighteen cultures. The American Indian collection, which is far more extensive, was an outgrowth of the school's Indian department, founded in 1878 to help assimilate Indians into the mainstream of society. The holdings represent a total of ninety-three tribes, but more than half consists of Plains Indians material. Ranking equally in quality and importance with the American Indian collection is the African collection. Although all regions of Africa are represented, the core of the holdings is from the Congo. It was purchased in 1911 from a former Hampton student who had been an explorer as well as a missionary in the Congo for twenty years. The museum has over 1,200 pieces in a variety of media representing African-American art from the nineteenth and twentieth centuries. The keystone of this collection was established in 1967 with a gift from the Harmon Foundation. Its strength is in paintings and works on paper—prints, drawings, and photographs—from the Harlem Renaissance. The museum also has nine paintings by Henry Tanner as well as work by distinguished contemporary black artists. Finally, there are two smaller collections: prints and objects from Japan and the Philippines, and a variety of material relating to the history of Hampton University.

The museum has a major gallery designated for its African material and another for its American Indian material. A smaller gallery is set aside for a selection of works from the Oceanic, Asian, and history collections. These galleries were installed on a semi-permanent basis in 1985 with a major grant from the National Endowment for the Humanities. The African-American art has also been allocated a major gallery space; except for a few key works, this material is rotated several times a year.

No more than 10 percent of the permanent collections are ever on display at any one time because of space constraints. Since the museum has outgrown its facility, Hampton is planning to provide larger quarters, which will be completely renovated to house the museum's valuable materials.

The Hampton University Museum is one of the outstanding institutions reviewed in this survey. Not only does it have one of the best collections among the black institutions, but it also has sound professional management—both museologically and administratively. Documentation is excellent; the holdings have been fully inventoried, accessioned, and catalogued. Although the museum does not have its own board, its governing body views the museum's mission as a priority and is highly supportive of the staff.

## Mexican Museum (San Francisco, California)

Founded in 1975 by Mexican-American artist Peter Rodriguez, the Mexican Museum's exhibition program and permanent collection focus on five principal areas: Pre-Conquest, Colonial, Folk, Mexican, and Mexican-American fine arts. Originally located in the city's Hispanic section, the museum moved in 1982 to a 10,000-square-foot renovated wharf building at Fort Mason Center, a 350,000-square-foot complex overlooking San Francisco Bay that houses more than fifty nonprofit organizations. The museum is the largest tenant at Fort Mason.

The Mexican Museum has been the site of several important exhibitions in recent years, including a show of the works of Diego Rivera and another of Frieda Kahlo. As a result of its programming and the quality of its growing collections, it has in the brief period of its existence become an important resource for the Mexican-American community.

Although the move to Fort Mason has resulted in a large increase in attendance and much greater audience diversity, the museum's leaders believe that it is not adequately addressing the needs of its primary constituents, who live in the Mission District. A related concern is that the concentration of groups at Fort Mason lessens the museum's impact as a unique institution. A more recent difficulty is lack of space. Expanding collections and burgeoning programs have caused the museum to outgrow its facility. For all these reasons, the board has concluded that the museum should relocate to a permanent site in San Francisco's Hispanic community. A plan is being developed to purchase, renovate, and endow a new facility in a building across from the Mission Dolores.

The Mexican Museum has a diversified income base, with about 25 percent coming from government sources, including city, state, and federal. Approximately 40 percent is derived from earned income, with La Tienda, the museum's successful store, contributing substantially. Another 30 percent comes from foundation and corporate support.

The museum has nearly 5,000 objects, including some 3,500 items of folk art. The core of the folk art collection is the result of a gift of more than 500 pieces from the Nelson A. Rockefeller Collection of Mexican Folk Art. There are also significant holdings of pre-Hispanic and Colonial art, and the museum has an aggressive policy of collecting contemporary Mexican and Mexican-American fine art. Approximately 3,500 square feet of the 10,000 square feet occupied by the museum has been turned over to collections storage. The space was recently upgraded with high-density mobile storage units, flat files, painting storage racks, special lighting, and improved security systems; however, it still lacks temperature and humidity controls.

## El Museo del Barrio (New York, New York)

El Museo del Barrio was founded in 1969 by artist Rafael Ortiz and incorporated in 1972. Initially located in a storefront and operating as an adjunct to the

local school district, the museum moved to its present site on Museum Mile (Fifth Avenue and 104th Street) in 1977.

El Museo occupies 20,000 square feet in a building owned by New York City and operated under the jurisdiction of the city's Department of Real Properties. There are twelve tenants in the building, among which the Department of Parks and Recreation, Boys Harbor, and El Museo are the principal ones. In the past year, as compensation for the loss of some office and storage space to the Department of Parks and Recreation, the museum was given the adjoining Heckscher Theater. El Museo considered turning the theater into exhibition and/or storage space, but decided to renovate and maintain it as a presenting space. The museum owns a four-story eighteenth-century firehouse on 104th Street between Lexington and Third Avenues. It plans to use this site as a satellite gallery, as space for artists-in-residence, or for workshops and other educational activities.

In fiscal year 1987 El Museo received 86 percent of its $600,000 annual revenue from two government sources: the New York City Department of Cultural Affairs (DCA) and the New York State Council on the Arts, with DCA contributing nearly 90 percent ($466,000) of the total. Over one-third of the funds from DCA is earmarked as direct rental payment for the museum's facility, including the theater. This high dependency on a single donor is of concern to the director as well as to the board, which is aware of the need to expand the organization's donor base.

El Museo has three principal collections: a large selection of prints, drawings, and photographs from Puerto Rico and Latin America; the largest public collection of Puerto Rican *santos*; and over 600 paintings—most of the artistic output—of the Puerto Rican painter Eloy Blanco. It has another 350 paintings by other Latin American and Hispanic American artists, a collection of pre-Columbian artifacts, miscellaneous items of folk art, and about 500 historic photographs. Although inventoried, the collection has not been accessioned or catalogued; this must be done to permit research to be undertaken on the collection. The items, currently stored in four separate rooms, will soon be consolidated in a central space that has been outfitted with new painting racks, shelving, and flat files. There are, however, no temperature or humidity controls.

Although it is an art museum, El Museo also presents film and theater festivals and concerts of chamber and Latin American folk music and hosts bilingual lectures and symposia that supplement its exhibition program. Its position as the foremost Hispanic visual arts organization in New York City—and one of the most important in the country—makes El Museo a vital resource.

## Museo de Antropologia, Historia y Arte (Rio Piedras, Puerto Rico)

The Museum of Anthropology, History and Art is located at the entrance to the Rio Piedras campus of the University of Puerto Rico. It was founded in 1951 by a professor of history at the university to exhibit his finds from excavations as

well as the artifacts donated to the university by private collectors. In the 1950s the university commissioned a building for the museum, to be constructed in five stages. To date only the first stage has been completed. Intended initially for only curatorial and administrative services, the building has had to encompass all of the museum's functions, with the exception of storage of the archaeological collections. It is now completely inadequate for the needs of the museum.

At present the galleries and the administrative wing open onto an outside courtyard through glass doors and are connected by means of open-air corridors. Because of its constricted space, the museum has expanded its galleries into the open-air corridors, where paintings hang for up to two months. Besides the damage from exposure, there is no security in this area except for an easily scaled metal-grate gate between the street and the courtyard. At the least, the building's exhibition halls, storage for the art collection, and administrative offices should be enlarged and renovated to include central temperature and humidity controls, security, and fireproofing.

The museum also has access to two smaller buildings for its archaeological collections. Most of them are located in a small three-story house, the Casa Margarida, which is just outside the gates of the main building. Under the supervision of the new archaeological curator, these collections have been systematically organized in plastic bins on open steel shelving. A smaller selection of archaeological material is located at another building, the Edificio de Hostos, under the supervision of the Center for Archaeological Research.

The museum has the largest holdings of the work of Francisco Oller, the great nineteenth-century Puerto Rican painter, as well as a sizable collection of the paintings of Jose Campeche. It also has a major and continually expanding collection of twentieth-century paintings and graphics by Puerto Rican artists and a selection of Egyptian material, including three mummies. The art collection—paintings, graphics, and documents—has been fully inventoried and catalogued. The archaeological collections, which are far more extensive, and are the most important such materials in the world, have not. An inventory check has begun, a computer has been purchased, and the new curator has begun to establish the nomenclature in preparation for revising the cataloguing system. There is a good effort at collections care and management at this museum, and accreditation is a clear goal—albeit a long-term one. This university museum, because of the nature, strength, and extent of its collections as well as the research and teaching focus of its current administration, has the potential to become Puerto Rico's state museum of cultural history.

## Museum of African-American Art (Los Angeles, California)

The Museum of African-American Art (MAAA) was founded in 1976 by Samella Lewis, a professor of art history at Scripps College, and a group of academic, artistic, and community leaders. What sets it so clearly apart from other American museums is its location: a department store, specifically, the third floor of

the May Company in the Crenshaw Shopping Center. Approached through housewares, the museum occupies approximately 6,000 square feet on this level, with an additional 1,000 square feet of storage space in the basement. The third-floor space is imaginatively divided to accommodate a sizable office, a gift shop, a combined storage and preparation area, and a large gallery. MAAA has a lease with the May Company through 1994 at $1 per year. The shopping center is currently in the midst of a renovation and expansion that will result in a covered mall, and the museum believes that it may be given larger and more visible quarters. Currently, the museum attracts an average of 1,000 visitors a month and charges no admission.

There are clear advantages to its location in that it is free, stable, and provides a built-in audience from the immediate community. The principal disadvantage is that it is such an unorthodox setting for a museum that there is a problem of credibility with the donor community as well as with mainstream museums and museum visitors.

MAAA is one of the very few institutions in the survey that has no ongoing source of support, such as a line item from the state or municipal government or an annual appropriation from a parent organization. Its operating budget fluctuates depending on the nature and "fundability" of its exhibition schedule and the success of its annual fund-raising event. The staff is small and almost all work on a part-time basis (the museum is open only four days a week). The trustees are hard-working, with a strong commitment to sustaining the museum.

The MAAA collection is significant for its holdings of fifty paintings by Palmer Hayden, one of the more prominent artists of the Harlem Renaissance. The remainder of the holdings consists of approximately forty pieces—primarily works on paper (prints, drawings, and photographs)—by African-American artists from the 1960s, ten Haitian paintings, and about fifteen minor African pieces.

The museum's exhibition program has focused on the work of contemporary African-American artists. Occasional exhibitions highlight the work of a twentieth-century master such as Jacob Lawrence or Palmer Hayden. The catalogues of these exhibitions are particularly important because of the lack of other publications on these artists. The museum has also established a videotape library of recordings of its exhibitions as well as interviews with established and emerging African-American artists.

It is worth noting that the Museum of African-American Art is the only non-university black museum west of the Hudson with an exclusive focus on art.

## Museum of African-American Life and Culture (Dallas, Texas)

The Museum of African-American Life and Culture was established in 1974 in the basement of the library of Bishop College in southeastern Dallas. It was originally a program of the college. With the decline of Bishop College, the museum

gained autonomy and has been operating independently since 1979. In 1988 the museum relocated to temporary quarters in Fair Park, a fairground that was the site of the 1936 Texas Centennial Exposition. It shares office space with a local classical radio station and mounts exhibitions off-site while it awaits the construction of its facility in Fair Park. The new 30,000-square-foot building, which will cost an estimated $3 million, will catapult the museum from relative obscurity to a position of visibility and prominence among such neighboring institutions as the Dallas Museum of Natural History, the Dallas Historical Society, the Science and Technology Museum, and the Aquarium.

The museum defines its mission as the identification, selection, acquisition, presentation, and preservation of visual art forms and historical documents that relate to the life and culture of the African-American community, particularly in Dallas and other parts of the U.S. Southwest. The museum's collections and collecting policy are consistent with this mission. Although the holdings are small, they are not inconsequential. They consist of approximately 215 paintings, prints, drawings, and photographs by contemporary African-American artists; 410 objects, including masks, other ceremonial pieces, and gold weights, primarily from West Africa, from the nineteenth century to the present; and a black folk art collection of about fifty items. An informal acquisitions group was recently organized to raise funds to increase and strengthen the holdings in black folk art. Additionally, because of its historical focus, the museum has been acquiring primary source material on prominent black Texans as well as developing an oral history collection on the evolution of the black community in Texas.

The museum has a committed—and sizable—board made up of a cross section of the community. All trustees are required to attend training sessions to learn their legal and fiduciary responsibilities. The museum also benefits from an informal affiliation with the Dallas Museum of Fine Arts. The museum's staff is adequate in size for its present activities. With the move to a new and larger facility, however, some expansion in staff will be necessary.

The museum has operated with a balanced budget or a surplus every year since its founding, the result of prudent management and a diversified base of support. Approximately 22 percent of its annual operating budget in fiscal year 1987 came from local, state, and federal grants. Another 36 percent came from foundations and corporate sources. The remainder was raised through individual donations, earned revenues, and, most importantly, through fund-raising events.

The museum has a $125,000 reserve fund established by the Meadows Foundation. Once the capital drive for the building is concluded, a second drive will be mounted to raise endowment funds to help cover the increased operating costs of the new facility. The new site will give the museum a much higher profile and greater accessibility to a broader segment of the public, including the black community.

## Museum of the National Center of Afro-American Artists (Boston, Massachusetts)

The National Center of Afro-American Artists is a multidisciplinary cultural and educational institution founded in 1968 to preserve and promulgate the artistic heritage of black people. As the visual arts component of the center, the museum is committed to the promotion, exhibition, collection, and criticism of art stemming from the black heritage, with an emphasis on the art and artifacts of African-Americans.

The museum is governed by the center's small board of trustees, but has an advisory board of its own whose chairman serves on the center's board. Though it has no policy-making authority, the advisory board functions as an advocate and fund raiser for the museum. The center provides the museum with a degree of administrative support and assistance with financial management, development, and public relations.

The museum building, a late nineteenth-century stone mansion, was purchased from the City of Boston for $1 in 1976. After considerable renovation in the early 1980s, about half of the 17,000-square-foot facility was transformed into gallery, storage, and administrative space and opened to the public. The museum is about to launch a full renovation of the site, including the grounds, which will solve its most urgent problems of climate control and storage and office space. The project will be underwritten with $4 million from the Heritage Parks program of the city's Department of Environmental Management.

The museum's exclusive focus on art is reflected in its collections and in its acquisitions policy. Since 1969 it has amassed more than 2,500 items, including approximately 1,100 African objects. Its more important holdings, however, are in the areas of prints and drawings by African-American artists from the nineteenth and twentieth centuries. Although the museum also has a small cache of African-American paintings and sculpture, the museum director has decided to focus on works on paper—prints, drawings, and photographs—reflecting not only cost constraints but also problems of storage and collections care. The collection has been completely inventoried, accessioned, and catalogued. Stored on site, it has adequate security and localized climate control.

Since 1969 the museum has had a unique, mutually beneficial collaborative relationship with the Boston Museum of Fine Arts (MFA). The key element in this symbiosis is Barry Gaither, who not only serves as the director of the MNCAAA but also as a special consultant to the MFA. To date, Gaither has curated eight major shows for the MFA. In turn, the MFA provides direct cash support of approximately one-quarter of the museum's annual operating budget, staff development assistance, and conservation materials and services. It also cosponsors several education programs.

The Museum of the National Center of Afro-American Artists is one of the few non-university black museums focused exclusively on art. Under the strong leadership and tenacity of its director, it has become the repository of an important and growing collection of African-American graphic art, the originator, in

concert with the Boston Museum of Fine Arts, of many important African and African-American exhibitions, and the site of a unique slide library of contemporary African-American work.

## The Studio Museum in Harlem (New York, New York)

The concept for the Studio Museum was first "floated" in 1966 by the Junior Council of New York's Museum of Modern Art. The founders wanted to establish an uptown contemporary art space focused on experimental art and showcasing the work of both black and white artists. The intent was to avoid having a traditional museum with a permanent collection, but rather to concentrate on an innovative exhibition and film program and a strong artist-in-residence program that would provide a "studio" experience for community artists.

The Studio Museum was incorporated in 1967 and the following year opened to the public in a loft. In 1977 it began a period of considerable growth and maturation when Mary Schmidt Campbell, an art historian, was named director. She served until 1987 when she was appointed Commissioner of Cultural Affairs for New York City. During her decade of leadership the institution made a quantum leap forward and in July 1987 it became the first black museum to be accredited by the American Association of Museums. It is the largest museum in the survey, with respect to operating budget and staff size. The Studio Museum now defines its mission as the collection, documentation, and critical analysis of the art and artifacts of black America and the African Diaspora.

In 1979 the New York Bank for Savings gave the Studio Museum the land and building it currently occupies in the heart of Harlem on West 125th Street across from the New York State Office Building and within sight of the Apollo Theater. After extensive renovations (funded principally by an Urban Development Action Grant from the federal government's Department of Housing and Urban Development, and by a Program-Related Investment by the Ford Foundation), the museum moved into the building in 1981 and opened its galleries to the public in 1982. The Studio Museum occupies the lower three floors and basement and leases the upper floors to not-for-profit tenants. The 34,800 square feet the museum maintains for its own use provides it with ample exhibition and storage space, administrative offices, a gift shop, a study center for the Van Der Zee photo archives, and workshop and studio space for resident artists. New York City recently gave the museum a vacant lot adjacent to its building for a sculpture garden.

Through a contractual agreement with New York State, the Studio Museum has since 1978 been providing curatorial services for the Adam Clayton Powell, Jr., State Office Building Gallery. This quasi-satellite space is very important, not only as a service to a large segment of the public that normally never visits museums, but also as a means of audience development for the main facility.

The Studio Museum's holdings consist of the Van Der Zee Collection (about 10,000 prints and negatives) and approximately 1,100 other items, including educational films and videotapes. The holdings can be grouped into three broad categories: traditional and contemporary African art and artifacts; twentieth-century Caribbean art; and twentieth-century African-American art. The collection has been inventoried, accessioned, and about three-quarters of it, except for the Van Der Zee material, has been catalogued. A complete conservation analysis has also been conducted. The museum has an aggressive and focused acquisition plan directed toward improving and expanding its current areas of strength.

The Studio Museum is one of New York City's thirty-two "cultural institutions," a category that signifies a "collaborative partnership" with the city. One of the many benefits of this alliance is an annual line item from the city through the Department of Cultural Affairs (DCA). In fiscal year 1987 DCA provided one-quarter of the museum's total income. Some 25 percent of the museum's budget comes from a range of other government sources, including the National Endowment for the Arts (NEA), the National Endowment for the Humanities (NEH), the Institute of Museum Services (IMS), and the New York State Council on the Arts. Another 23 percent comes from foundations and corporations; and the remaining 27 percent comes from such earned income as memberships, individual contributions, and rent from its not-for-profit tenants. The museum's ability to tap the NEA, NEH, and particularly the IMS on a consistent basis and at high levels sets it apart from other museums in the survey. Its long-term goal is to increase its working capital reserve to $500,000 by 1992.

The Studio Museum in Harlem is nationally recognized as the premier black art museum in the United States. Its sophistication and professionalism in both managerial and programmatic areas have made it a model for all black museums.

# RECOMMENDATIONS

Based on the data gathered from the questionnaire, the site visits, and the numerous interviews with professionals in the field, several conclusions emerge.

Black and Hispanic art museums share with other museums a need to improve the care, organization, and documentation of their collections. This was the key priority identified by the Commission on Museums for a New Century[1] and echoed two years later by the International Council of Museums, which called upon the nation "to give the highest priority to the preservation of the cultural material heritage."[2] The magnitude of the problem for black institutions has been underscored by two recent publications: the 1987 survey conducted by the African American Museums Association[3] and Amina Dickerson's article on African-American museums.[4] The results of the present study confirm the urgency and scope of the problem for art museums in both the black and Hispanic communities and clearly identify collections as the necessary focus of any new program created to strengthen and stabilize these museums.

Two other areas of critical need are institutional development and professional training. The economic fragility of many of the museums in the study is illustrated by the statistical findings and was noted overwhelmingly by those interviewed.

Inadequate funding causes all manner of problems, from insufficient staff to meet basic needs and minimum standards to poor visibility even within the immediate community. Targeted assistance to promising institutions can strengthen their key operations and bring them greater stability and resilience.

As for professional training, only a small percentage of the personnel and trustees of these groups have museum or art history training or experience. Though support is needed for all levels of scholarship and instruction, there is particular need for technical assistance and interim training for existing museum staff.

## THE COLLECTIONS

**Management.**  According to museum consultant Joy Norman, "A sound collections management program is critical to all other services that emanate from a museum's collections."[5] This statement establishes the primacy of good record-

keeping systems, which is how a museum's holdings are controlled and managed. Management encompasses not only the care and maintenance of a collection but also the collection's use for scholarly research, display, and general programming. According to the foregoing statistical analysis, 75 percent of the institutions in the study that had collections have conducted inventories of their holdings. (The data, unfortunately, do not indicate how recently the inventories were undertaken or how complete they are.) Although this is encouraging, an inventory is the least complex and most basic of the necessary systems, generally providing no more than an identifying number, the name of the object, and its location. Only 58 percent of the groups had registration or accession records and fewer than half—42 percent—had catalogued their holdings. A well-designed cataloguing system with clearly defined nomenclature can provide a great deal of information, including a full physical description of an object (material, size, color, etc.), its provenance and history, donor information, and bibliographic details. If sufficiently inclusive and adequately cross-indexed, a sound cataloguing system can make a collection truly accessible. Supplemented with photographic documentation, it can serve "as a buffer, allowing the collections to be used actively without physical handling,"[6] thus decreasing "handling-related degradation" and paying eventual "dividends in conservation."[7]

**Maintenance.** Collections maintenance, "the basic activities that insure the security and maintenance of the physical environment,"[8] is as critical as collections management. The adequacy of the facility is all-important for collections care. As Joy Norman writes,

> An inadequate physical environment is one of the greatest causes of deterioration; improving the environment may be the single most important factor in preventing further decline.[9]

According to the survey, only one-third of the institutions indicated that their structure was sufficient for the maintenance of their collections; no more than four stated that they had adequate storage space. The greatest needs for the groups in question are new or upgraded climate control systems and storage equipment. Only by upgrading conditions will it be possible to stabilize "the finite and non-renewable resources"[10] of these collections.

Besides the urgent necessity to update their collections management systems, the greatest needs for the museums surveyed are: facility studies to gauge environmental conditions for the preservation of objects; storage units that increase capacity while providing greater protection and access (for example, metal cabinets, flat files, movable steel shelving, and hanging screen panels for paintings); climate and security control systems, ranging from modifying light levels to the installation of heating, ventilation, and air conditioning systems, and humidity controls, specifically in permanent galleries and storage areas.

**Conservation.** The key component of a successful conservation program is a general survey. It provides a broad perspective of the state of the collection,

identifies priorities for the care of specific objects, and enables the organization to formulate a long-range conservation plan. Only 42 percent of the collecting institutions in the study have conducted general surveys of their holdings. Thus, for most of the museums the degree of care needed is inadequately quantified.

Conservation is expensive, requiring continuing vigilance by staff, specialized professional expertise, and costly equipment and materials. Most institutions engage in treatment either on an emergency basis or when objects are required for an upcoming exhibition. Frequently, such work is undertaken with special project funds or with support from an exhibition grant if treatment is part of the package. Few museums engage in preservation or restoration on any regular basis. This is particularly the case with the museums under review.

Black and Hispanic museums need support to conduct general and/or detailed condition surveys of their entire collections or segments of them as well as surveys of environmental conditions to assess conservation needs and priorities. They need support also for the services of professionals to treat specific objects or groups of objects. Priority should be given to assisting institutions that can ensure a sound environment for the treated object and/or to those that are in the process of improving storage and exhibition spaces.

To sum up, collections management, maintenance, and conservation are the key needs of the groups in the survey. Besides these urgent priorities, however, are concerns relating to the didactic value and use of the collections.

**Publications.** The survey revealed that only four of the museums have produced publications on their holdings. Many other museums, however, also have collections that should be fully researched, documented, and published either in their entirety or at least selectively. Furthermore, to increase community access, gallery guides and educational packets directed to primary and secondary schools—and, of course, to the general visitor—should be produced. In the case of Hispanic museums, all printed material should be available in both Spanish and English.

**Exhibitions.** Although all of the institutions have changing exhibitions of some kind throughout the year, there is an enormous range in their scope and professionalism. The limiting factor, almost invariably, is funding. Only five of the museums said their staffing was adequate for their current exhibition programs. Lack of resources limits not only the necessary research to prepare a show, but also everything else, from the nature of the fabrication material to the level of promotion. Funding determines the scope of the exhibit publication, including the number of reproductions in it, and whether or not the show is to travel. Mounting major exhibitions is well within the ability of many of these museums, albeit extremely taxing if done with only existing staff. Funds are needed particularly to mount ambitious exhibitions that not only fulfill scholarly expectations but also awaken the public, including the immediate community served, to the artistic achievements of black and Hispanic peoples.

***Permanent Installations.*** Many of the museums in the survey have segments of their collections on permanent view. In many instances, however, these displays are antiquated in design and in didactic value. Labels are peeling and often contain information that is inconsistent with current scholarship; cases are damaged; the installation designs are uninspired. Support to re-install this material would provide an important service to these museums.

## ACQUISITIONS

A major function of black and Hispanic art museums is the stewardship of their cultural patrimony. Many mainstream institutions collect African art and some collect the masters of African-American and Hispanic art but, in general, they have not collected the works of black and Hispanic Americans in any systematic way. Mainstream institutions that have sizable holdings in these areas rarely exhibit more than a small percentage of them, since the display and interpretation of this material is not their central mission.

For different reasons, many black and Hispanic museums have not been collecting systematically, either. One reason is the relative youth of these institutions and the nature of their genesis. In most cases, original mission statements were broad or ambiguous. The emphasis was on cultural expression, community-related activities, and support for contemporary artists. Collections tended to be an afterthought. Lack of funds was a key factor as well. Some museums began collecting without a formal policy, sometimes accepting donations unrelated even to their all-inclusive missions.[11] The goal, in some instances, was to fill up their galleries in order to gain legitimacy as museums. Since none of these museums has the resources to be encyclopedic, almost all will have to undertake some degree of deaccessioning once they have decided upon clear, realistic collections policies that are in harmony with their mission statements. Stephen Weil, citing a presentation by Washington architect George E. Hartman, Jr., observed in 1983 that "the annual cost to heat, cool, clean, and guard the space in which museum objects are stored was $25 per square foot,"[12] and that did not take into account the initial costs of construction or "the expenses of taking periodic inventories, maintaining records, and making condition surveys."[13] Few museums— especially the smaller, less well endowed institutions—have the resources to be custodians of objects that are inappropriate for their collections. As Weil further notes, deaccessioning can produce much-needed funds for the purchase of work that enhances a collection.[14] Support to assist acquisitions by institutions with a clearly defined collections policy and a commitment to collections management and maintenance could have a significant impact in the field.

## INSTITUTIONAL DEVELOPMENT

The infrastructure of many of these museums is fragile. As the survey indicated, over half of the museums' annual income is derived from government sources. Indeed, for several of them federal, state, or municipal funds support core operating staff. Government support, however, has not kept pace with the growing needs of expansion, and funding from the private sector has been slow to develop. One reason is that the communities served are themselves economically fragile. Another is that the senior management and boards of these institutions have not yet developed sufficiently strong relations with corporate and foundation funders. Earned income, an element that is generally highly dependent on attendance, will not be a major source of revenue until these institutions can market themselves more effectively to attract larger audiences.

Institutional development might be practically addressed through the provision of multi-year support targeted to specific functional areas or departments within a museum for the development of new programs or the expansion of existing ones. An important aspect of institutional development, and of particular significance to most of these organizations, is audience development. Promotional campaigns should be mounted, and sustained, within the communities served by the museums to ensure that the local audiences are aware of the museums' existence. Funding is needed for audience surveys, membership materials, direct mail campaigns, newsletters, and special public programs. Innovative means of mass promotion should be encouraged—for example, billboards or subway and bus posters designed by black or Hispanic artists, specific exhibitions, or special events. Collaborations with other museums, such as jointly produced calendars of events or direct mail campaigns, ought to be encouraged as well.

Measuring the results of support for institutional development is more difficult than gauging the success of a grant to catalogue a collection. Nonetheless, development support is vital to the growth of these institutions. It is evident that many of them need substantial infusions of money for specific operational areas. Although such support may be riskier for funders than grants for storage equipment, conservation, or exhibitions, it is essential for the professional maturation of these museums.

## TRAINING AND RESEARCH PROGRAMS

In *Museums for a New Century*, the American Association of Museums expressed its concern that the "cultural pluralism that museums celebrate is not manifested in the composition of museum staff."[15] The study goes on to note that the museums in the AAM's monitoring system "reported that only 5 percent of their staffs are black, and most of those people work in maintenance and security jobs."[16] Confounding the mainstream institutions that might wish to alter this balance is the relative dearth of minorities in the academic pipeline leading to

museum professions. This lack of available trained personnel affects black and Hispanic museums even more severely because they can offer less remuneration. Museum careers are frequently bypassed by blacks and Hispanics for more lucrative and stable careers in academia, the professions, or the corporate world.

An even more pressing need for minority museums is the training of existing staff. Although this issue was not probed in the survey, it was repeatedly cited as a pervasive and urgent need during the site visits. A regional study conducted by Joan Sandler under the auspices of the Metropolitan Museum of Art in New York on the problems and needs of minority art museum professionals confirmed the perception that training and development needs loom large and "appear to be greatest at the middle level of the profession."[17] The principal suggestion offered by the respondents was to strengthen mid-career training opportunities, emphasizing "short-term programs that require minimal disruption of work activities and can be comfortably integrated into existing schedules."[18]

Black and Hispanic museum professionals, particularly those at mid-career or just at the beginning, could benefit from attending workshops in such areas as collections care and management, public programming, exhibition design, governance, long-range planning, and fund raising. Beyond the needs of staff, it is evident that training opportunities ought to be made available to board members as well with regard to their responsibilities as trustees. Excellent museum workshop programs that cover these and other areas are offered by the Smithsonian Institution, the Metropolitan Museum of Art in New York, and by several regional service organizations.[19] The workshops generally last two to five days and offer participants the additional advantages of networking, sharing experiences and information, and comparing the performance of one's own museum with that of others. An alternative that may be more suitable for some institutions is an on-site training program customized to the specific needs of the museum. This might be particularly beneficial in cases where a museum is involved in institutional planning and a large number of people—staff and trustees—are involved in the training process.

Somewhat related to the above, but designed to address specific problems, are technical assistance programs that could provide specialists around the country who would be available for consultation on a variety of subjects. Many of the museums under review need technical assistance in a wide variety of areas, from conservation to accounting.

There is also a paucity of internship opportunities for minorities, as highlighted by the Metropolitan Museum study.[20] A six- to twelve-month internship in a strong and well-run museum provides an excellent vantage point from which an aspiring professional can observe at first hand the opportunities available in the field. It is essential that the host museum provide the intern with a good mentor, access to senior staff, and detailed information about the organization. Internships in museums frequently lead to jobs in the host institution or, as a result of the networking possibilities available in this small community, in

another museum. The survey revealed that internships in this field are generally unpaid. Although fourteen, or nearly half of the groups, stated that they offered internships, only four carried stipends. Compensation is an important factor in attracting the most promising candidates.[21]

Research endowments would be another important contribution. The lack of opportunities to study Hispanic and African-American art is a source of continual frustration in the field. By sponsoring residencies for scholars at institutions with recognized collections of African, African-American, or Hispanic art or by endowing chairs in these areas at major universities with strong art history departments, a significant research vacuum could be filled.

## CONCLUSION

Support based on the above recommendations would have a measurable impact on these institutions. In particular, support is urgently needed to protect and stabilize the collections, to ensure that the cultural heritage of these communities does not disappear as a result of neglect and lack of resources. Beyond immediate attention for the collections is the need to strengthen the institutions themselves and the professionalism of their staffs. As noted, only one of these museums is accredited. Combined efforts directed toward the care and development of collections along with a focus on institutional development and staff training should result in the accreditation of several others in five to ten years.

# NOTES

1. American Association of Museums, *Museums for a New Century.* Washington, D.C., 1984, p. 30.

2. Ellen Herscher, "ICOM in Buenos Aires," *Museum News,* February 1987, p. 35.

3. African American Museums Association. 1987. *A Survey of Black Museums.* Washington, D.C.: African American Museums Association, pp. vii-x.

4. Amina J. Dickerson, "African-American Museums: A Past Filled with Pride, A Future Filled with Challenges," *The Journal of Arts Management and Law,* Vol. 18, no. 2 (Summer 1988), pp. 46-48.

5. Joy Youmans Norman, "Caring for the Nation's Common Wealth: Collection Needs in Twelve Museums," *Museum News,* October 1985, p. 52.

6. Peter H. Welsh and Steven A. LeBlanc, "Computer Literacy and Collections Management," *Museum News,* June 1987, p. 43.

7. *Ibid.*

8. Jane Slate, "Caring for the Nation's Common Wealth: A National Study Assesses Collections Management, Maintenance and Conservation," *Museum News,* October 1985, p. 39.

9. Norman, *op. cit.,* p. 47.

10. Susan J. Bandes, "Caring for Collections: Strategies for Conservation and Documentation," *Museum News,* October 1984, p. 70.

11. Some unusual objects include a large equestrian statue from Southeast Asia, Egyptian mummies, and a medieval devotional painting.

12. Stephen E. Weil, "Deaccession Practices in American Museums," *Museum News,* February 1987, p. 45.

13. *Ibid.*

14. *Ibid.*

15. American Association of Museums, *op.cit.,* p. 82.

16. *Ibid.,* p. 83.

17. Joan Sandler, "Minority Art Museum Professionals in Northeastern and Mid-Atlantic States: An Exploratory Study of Their Problems and Needs," unpublished manuscript, p. 25.

18. *Ibid.,* ii.

19. The Museum Management Institute, a program of the J. Paul Getty Trust, offers a monthlong program at the University of California, Berkeley, for middle-level and senior museum personnel. It is offered only once a year and entrance is highly competitive; it is probably the best training program of its kind in the country.

20. "Minority Art Museum Professionals...," p. 4.

21. *Ibid.*

# APPENDIX A.
# QUESTIONNAIRE

BLACK AND HISPANIC ART MUSEUMS
SURVEY    1986

A SERVICE TO THE MUSEUM FIELD
FUNDED BY

THE FORD FOUNDATION

DIRECTED BY

THE STUDIO MUSEUM IN HARLEM

PROJECT DIRECTOR:

    DR. MARY SCHMIDT CAMPBELL

PROJECT CONSULTANTS:

    DR. DEWEY F. MOSBY
    SR. IRVINE R. MAC MANUS

CONTENTS                                    PAGE

```
FILL  IN:

Organization name _____

Also known as (if any other name is used) _____

Address _____
City _____
State _____
Zip _____
Respondent's name _____
Position _____
Director's name _____
Mailing address (if different from above) _____
_____
_____

Organization telephone (    )
Year established            _____

INSTRUCTIONS : PLEASE USE A CHECK MARK IN ALL QUESTIONS EXCEPT
WHERE SPACE IS PROVIDED FOR YOUR  OWN COMMENTS .

THANK YOU FOR YOUR COOPERATION IN ADVANCE .

                                                       iii
```

# ORGANIZATION
## and TRUSTEESHIP

Is your museum charted as a non-profit organization?    YES ___ NO ___
Is your museum an independent entity?         _____     (check one)
Is your museum Affiliated with a college?      _____
Is your museum Affiliated with a university?   _____

Please provide name of Affiliated Institution.

_____
_____

Does the museum have a Board of Trustees or Board of Directors?
YES ___ NO ___
Does the museum have a clearly defined committee structure for the
Board of Trustees/Directors?
YES ___ NO ___
Does the museum have a Trustee Manual?         YES ___ NO ___
Do your members of the Board participate in any of the following?

Trustee Retreats?       YES ___ NO ___
Strategic Planning?     YES ___ NO ___
Legislative Training Programs?       YES ___ NO ___

If your museum were to receive an increase in funding, what steps
would you take to strengthen your Board?

_____
_____
_____
_____
_____
_____
_____
_____
_____

1

# FINANCES

In completing the questions below relating to finances, we would appreciate your estimating to the nearest $1,000.

What was your Total Operating Expense for your most recently completed fiscal year?      198_?

$\underline{\hspace{2cm}}$

What is your projected total operating expense for the current (or next) fiscal year?

_____ $25,000 - $75,000
_____ $75,000 - $200,000
_____ $200,000 - $500,000
_____ $500,000 - $750,000
_____ $750,000 - $1,000,000
_____ OVER $1 Million

What was your income (earned and contributed) for your most recently completed fiscal year (not including donated (in-kind) services and goods?

$\underline{\hspace{2cm}}$

Using figures from your most recently completed fiscal year, Please estimate what percentage of your total income comes from each of the following five sources.

_____ % earned income (admissions, performance fees, ticket sales, publications, tuition, memberships, etc.)
_____ % corporate / foundation funding
_____ % private / individual funding / gifts
_____ % donated (in-kind) services and / or goods
_____ % government funding (city, state, federal)

Did your organization invest in any major capital improvements during the past year?

_____ YES   If yes, give amount:

$\underline{\hspace{2cm}}$

_____ NO                                                    2

51

## FINANCES continued:

Does your museum carry a long term debt?
YES ___          If yes, please give amount:     $_____
NO ___

## ENDOWMENT

Does your museum have an Endowment?        YES ___ NO ___

Does your museum have a Reserve Fund?      YES ___ NO ___

What initiative has the museum taken to insure its financial
future?

_____
_____
_____
_____
_____

What are the museum's long term capital development plans?

_____
_____
_____
_____
_____

3

## FEDERAL AGENCY SUPPORT

Has your museum received a Challenge Grant from
the National Endowment for the Arts?          YES ___ NO ___
If yes, What Year? and in what Amount?     YEAR_____ Amount $_____

Has your museum received a Challenge Grant from
the National Endowment for the Humanities?     YES ___ NO ___
If yes, What Year? and in what Amount?     YEAR_____Amount $_____

Has your museum received an Advancement Program Grant from
the National Endowment for the Arts?          YES ___ NO ___
If yes, What Year? and in what Amount?     YEAR_____Amount $_____

Does your museum apply to the Institute of Museum Services (IMS)?
If yes, for what Year (s) ?   YEAR_____   Amount $_____
                              YEAR_____   Amount $_____
YES ___ NO ___

Did you receive an IMS GRANT?        YES ___ NO ___  Amount $_____

## STATE ARTS COUNCIL SUPPORT

How much did your STATE ARTS COUNCIL CONTRIBUTE to your museum?

1985     $ _____
1986     $ _____

## LOCAL ARTS COUNCIL SUPPORT

How much did your LOCAL ARTS COUNCIL CONTRIBUTE to your museum?

1985     $ _____
1986     $ _____

4

## PERSONNEL

How many persons does your museum employ?   TOTAL NUMBER _____
Under the titles below, please indicate number of people in each
and provide salary range.

| TITLES/POSITIONS | NUMBER | SALARY RANGE | FULL/PART TIME |
|---|---|---|---|
| PRESIDENT | _____ | _____ | _____ |
| DIRECTOR | _____ | _____ | _____ |
| CURATOR | _____ | _____ | _____ |
| ASSISTANT CURATORS | _____ | _____ | _____ |
| DEVELOPMENT DIRECTOR | _____ | _____ | _____ |
| DEVELOPMENT ASSISTANTS | _____ | _____ | _____ |
| EDUCATION DIRECTOR | _____ | _____ | _____ |
| EDUCATION ASSISTANTS | _____ | _____ | _____ |
| EXHIBITION SPECIALISTS | _____ | _____ | _____ |
| MEMBERSHIP | _____ | _____ | _____ |
| LEGAL COUNSEL | _____ | _____ | _____ |
| CONSERVATORS | _____ | _____ | _____ |
| ADMINISTRATION | _____ | _____ | _____ |
| FINANCIAL DIRECTOR | _____ | _____ | _____ |
| LIBRARY SERVICES | _____ | _____ | _____ |
| EDITORIAL AND PUBLISHING | _____ | _____ | _____ |
| SECURITY | _____ | _____ | _____ |
| TECHNICIANS | _____ | _____ | _____ |
| MAINTENANCE | _____ | _____ | _____ |

Does your institution offer Pension and Retirement Benefits? YES ____ NO ____

If you had additional funds, what positions would you add to your Staff?

_____

5

## PERSONNEL continued:

What qualifications do you seek in new personnel?

EDUCATIONAL BACKGROUND

_____

_____

_____

_____

_____

EXPERIENCE

_____

_____

_____

_____

TRAINING

_____

_____

_____

_____

What professional training opportunities do you provide to your staff?

_____

_____

_____

_____

6

# COLLECTIONS

Please indicate with a check mark if you have the following in your collections.

APPROX. NUMBER OF **WORKS**

____ PAINTINGS _____

____ SCULPTURE _____

____ DRAWINGS _____

____ PRINTS _____

____ PHOTOGRAPHS _____

____ FOLK ART _____

____ ARCHAEOLOGICAL _____

____ AFRICAN _____

____ PRE-COLOMBIAN _____

____ AMERICAN INDIAN _____

____ TEXTILES _____

____ COSTUMES _____

____ MURALS _____

____ FILMS _____

____ VIDEO _____

____ MUSICAL INSTRUMENTS _____

____ DECORATIVE ARTS _____

____ HISTORICAL ITEMS _____

____ BOOKS _____

____ CURRENT ART PUBLICATIONS _____

____ OTHER COLLECTIONS _____

TOTAL _____

Does the museum have an Archive?   YES ____ NO ____

Does the museum have a library?   YES ____ NO ____

7

## COLLECTIONS continued:

Please describe the highlights of your collection.

_____
_____
_____
_____

What are your future plans for the development of your collection?

_____
_____
_____
_____

If you are planning Accreditation, what steps are you taking?

_____
_____
_____
_____

8

## COLLECTION MANAGEMENT

What percentage of your collection is on permanent exhibition?
% _____ .

Is your collection inventoried?          YES ___ NO ___
Is your collection accessioned?          YES ___ NO ___
Is your collection catalogued?           YES ___ NO ___

What systems are utilized to record accessions, location and
de-acquisition of of works in the collection?   (check one)

          Manual Card File _____ or Computer System _____

Are the museums collections accessible to other museums?

                              YES ___ NO ___
                         to Scholars?
                              YES ___ NO ___

                         to Students?
                              YES ___ NO ___

Is there a published catalogue of the collections?
                              YES ___ NO ___

Is the current structure which you occupy suitable to the proper
function of caring for your collections and providing public access?
YES ___ NO ___
Is your current staffing appropriate for your collection management
needs ?
YES ___ NO ___

9

## COLLECTION MANAGEMENT
continued:

Please define your collection management needs in terms of space, staffing and equipment. _____

_____
_____
_____
_____
_____
_____
_____
_____
_____
_____
_____
_____

## CONSERVATION

Has the museum undertaken a conservation analysis of its collection?
YES ___ NO ___

Does your museum have a relationship with a regional conservation laboratory?
YES ___ NO ___

Please describe your current conservation activities _____
_____
_____

Describe your most urgent collection and conservation needs.
_____
_____
_____
_____
_____

10

## EXHIBITION PROGRAM

How many exhibitions does your museum mount each year? _____

Does the museum organize exhibitions from its own collections?
YES ___ NO ___

Does the museum have a written exhibition policy?     YES ___ NO ___
If yes , Please provide us with a copy.

Does the museum organize exhibitions for travel in the United States?
YES ___ NO ___

for travel to other Countries?
YES ___ NO ___

Has the museum organized exhibitions of the Art of other nations?
YES ___ NO ____     If YES, Please list which Countries.
_____
_____
_____

Is the staffing adequate for the types of exhibitions you mount?
YES ___ NO ___

What type of printed materials do you offer with your exhibitions?
_____
_____
_____

Please describe your future catalogue publication plans.
_____
_____
_____

Please describe your exhibition plans for the next year.
_____
_____
_____

What exhibitions and related programs would you like to present if
you had additional resources? _____
_____
_____
_____
_____
_____

11

# EDUCATION PROGRAMS

Does the museum prepare interpretive programs?　　YES ____ NO ____

Does the museum offer?　　(check all that apply)

_____ PUBLIC LECTURES　　　　　　_____ TEACHER TRAINING MATERIALS

_____ SYMPOSIA　　　　　　　　　　_____ SLIDES

_____ TOURS　　　　　　　　　　　　_____ PUBLICATIONS

_____ RECORDED TOURS　　　　　　　_____ ARTIST INFORMATION

_____ WORKSHOPS AND CLASSES　　　 _____ COMMUNITY OUT-REACH TO OTHER

　　　　　　　　　　　　　　　　　　　　　　　　INSTITUTIONS (Schools,

　　　　　　　　　　　　　　　　　　　　　　　　Hospitals, Businesses)

Does the museum offer other public events?

_____ MUSIC　　　　　　　_____ VIDEO

_____ DANCE　　　　　　　_____ PERFORMANCE  ART

_____ THEATRE　　　　　　_____ LITERATURE

_____ FILM　　　　　　　　_____ OTHER, PLEASE DESCRIBE

Does the museum have an Artist-in-Residence Program?　　YES ____ NO ____

Does the museum have an Education Program with any of the following?

_____ Another museum. Please Identify _____

_____ A College and or University Museum Studies Program

　　　　Please Identify _____

_____ Other, Please Identify _____

Do you offer? (check those offered)

_____ FELLOWSHIPS　　　　　　How Many? _____　　How Much $____

_____ INTERNSHIPS　　　　　　　　　　　_____　　　　　　_____

_____ SCHOLARSHIPS　　　　　　　　　　 _____　　　　　　_____

Please describe your Education Activities with schools of all levels.

_____

_____

_____

How would you like to see your Education Programs strengthened?

_____

_____

_____

_____

_____

12

## FACILITIES

Is you facility

_____ owned
_____ leased
_____ rented
_____ loaned
_____ other (Please Specify) _____

Does your facility have? :    ( check all that apply)

Adequate Climate Control in your exhibition areas?        YES ___ NO ___
Adequate Collection storage areas?                        YES ___ NO ___
Adequate Staff and Office space?                          YES ___ NO ___

Is your museum currently involved in a Physical Expansion?
                                                          YES ___ NO ___

If YES, Please Share Copies of Plans or Photographs.

Please describe what are your facility development needs?

_____
_____
_____
_____
_____
_____
_____
_____

_____

13

## ADMISSIONS

Do you charge admission?

____ YES  If yes, what is the average admission    $ ____

____ NO If no, is admission to exhibitions and to programs and / or
    performances by donation?

____ sometimes

____ YES  If by donation, what is suggested donation? $ ____

____ NO, admission is free

Do you offer reduced admission?

____ YES  If yes, check those that apply:

____ children (12 and under)

____ group discounts

____ handicapped

____ members

____ senior citizens

____ students

____ others

____ no

1 4

63

## AUDIENCE

Please estimate your total audience for the past year _____

Estimate the percentage of your audience in the following age
categories:

___ % 0 - 4 years
___ % 5 - 12 years
___ % 13 - 17 years
___ % 18 - 24 years
___ % 25 - 44 years
___ % 45 - 64 years
___ % 65 and over

Please estimate the percentage of the following categories of visitors:

___ % LOCAL
___ % COUNTY
___ % STATE
___ % REGIONAL
___ % NATIONAL
___ % INTERNATIONAL

Please estimate the percentage of your visitors in the following groups.

___ % BLACK
___ % HISPANIC
___ % WHITE
___ % OTHER

If you had additional financial resources, what steps would you take
to increase your attendance?

Please describe. _____
_____
_____
_____
_____

15

## MEMBERSHIP

How many members does your museum have?          TOTAL _____

What do you offer your Membership?_____

_____

_____

If you were to receive an increase in funding, what would you do to
increase your Membership? _____

_____

_____

What steps would take to increase individual contributions?

_____

_____

_____

_____

## PUBLICATIONS

What kind of publications does your museum produce?  Please describe.

_____

_____

Does the museum publish an Annual Report on its Programs and Financial
Status?          YES ___ NO ___

If YES, Please provide us with a copy.

## PROMOTION

Which of the following have you used to advertise your programs and
events?       ( check those used)

_____ LOCAL NEWSPAPER

_____ DIRECT MAIL

_____ OTHER NEWSPAPERS

_____ PAID RADIO / TV SPOTS

_____ POSTERS / FLYERS

_____ PUBLIC SERVICE RADIO / TV SPOTS

OTHER ( Please specify) _____

Do you advertise your programs and events in languages other than
English?          YES ___ NO ___

If YES, Please list languages used: _____

16

## DEVELOPMENT AND FUNDRAISING

Please use this page to describe your future Development and Fundraising
Plans and Projections.

What Management and or Administrative changes are you planning
to implement?

THANK YOU !

17

# APPENDIX B.
# DIRECTORY OF MUSEUMS SURVEYED

| Museums | Date Established | Governance | Budget Size | Endowment/ Reserve | Status of Facility | Est. Annual Attendance | Membership | Staff Size |
|---|---|---|---|---|---|---|---|---|
| Afro-American Historical and Cultural Museum<br>7th and Arch Streets<br>Philadelphia, PA 19106<br>(215) 574-0380<br>*Rowena Stewart, Director* | 1976 | Private | $1,000,000 | None | Leased from city | 175,000 | 4,000 | 30 F-T |
| Anacostia Museum<br>1901 Fort Place, SE<br>Washington, DC 20020<br>(202) 287-3369<br>*Zora Martin Felton, Acting Director* | 1967 | Federal | $950,000 | None | Owned | NA | NA | 20 F-T |
| The Bronx Museum of the Arts<br>1040 Grand Concourse<br>Bronx, NY 10456<br>(212) 681-6000<br>*Luis R. Cancel, Exec. Director* | 1971 | Private | $1,146,000 | None | Leased from city | 24,000 | 289 | 24 F-T<br>7 P-T |
| California Afro-American Museum<br>600 State Drive<br>Los Angeles, CA 90043<br>(213) 744-7432<br>*Jacqueline DeWalt, Acting Deputy Director* | 1979 | State | $1,250,000 | Reserve | Owned | NA | 600 | 13 F-T<br>1 P-T |

67

| Museums | Date Established | Governance | Budget Size | Endowment/ Reserve | Status of Facility | Est. Annual Attendance | Membership | Staff Size |
|---|---|---|---|---|---|---|---|---|
| Caribbean Cultural Center<br>408 West 58th Street<br>New York, NY 10019<br>(212) 307-7420<br>*Marta Vega, Director* | 1982 | Private | $700,000 | Endowment | Rented | 80,000 | 400 | 8 F-T |
| Chicano Humanities and Arts Council<br>1535 Platte<br>Denver, CO 80202<br>(303) 477-7733<br>*Carmen Atilano, Exec. Director* | 1978 | Private | $101,000 | None | Rented | 10,000 | 350 | 1 F-T<br>1 P-T |
| Cuban Museum of Arts and Culture<br>1300 Southwest 12th Avenue<br>Miami, FL 33129<br>(305) 858-8006<br>*Carlos M. Luis, Exec. Director* | 1975 | Private | $150,000 | Reserve | Leased from city | 7,500 | 1,500 | 3 F-T<br>4 P-T |
| DuSable Museum<br>740 East 56th Place<br>Chicago, IL 60637<br>(312) 947-0600<br>*Ramon Price, Director of Artistic Programming* | 1961 | Private | $954,000 | Endowment | Leased from city | 62,200 | 1,950 | 25 F-T |
| Fisk University<br>Carl Van Vechten Gallery<br>Stieglitz Collection of Modern Art<br>P.O. Box 2<br>Nashville, TN 37203<br>(615) 329-8543<br>*Pearl Creswell, Curator* | 1949 | University | $86,000 | None | Owned | 1,000 | 0 | 5 F-T |

| Museums | Date Established | Governance | Budget Size | Endowment/ Reserve | Status of Facility | Est. Annual Attendance | Membership | Staff Size |
|---|---|---|---|---|---|---|---|---|
| Fondo del Sol Visual Arts and Media Center— El Museo Latino/Multicultural 2112 R Street, NW Washington, DC 20008 (202) 483-2777 *Marc Zuver, Admin. Director* | 1973 | Private | $126,500 | None | Rented | 45,000 | 450 | 1 F-T 7 P-T |
| George Washington Carver Museum 165 Angelina Street Austin, TX 78702 (512) 472-4809 *Angela Medearis, Acting Curator* | 1980 | Municipal | $80,000 | None | Owned | 9,000 | 75 | 3 F-T |
| Hampton University University Museum Hampton, VA 23668 (804) 727-5308 *Jeanne Zeidler, Director* | 1868 | University | $105,900 | None | Owned | 15,000 | NA | 4 F-T |
| Howard University Gallery of Art 2455-6th Street, NW Washington, DC 20059 (202) 636-6100 *Tritobia Benjamin, Director* | 1929 | University | Under $100,000 | None | Owned | NA | 0 | NA |

| Museums | Date Established | Governance | Budget Size | Endowment/ Reserve | Status of Facility | Est. Annual Attendance | Membership | Staff Size |
|---|---|---|---|---|---|---|---|---|
| The Mexican Museum<br>Fort Mason Center, Building D<br>Laguna and Marina Boulevard<br>San Francisco, CA 94123<br>(415) 441-0445<br>*Marie Acosta-Colon, Exec. Director* | 1975 | Private | $800,000 | Reserve | Leased | 90,000 | 800 | 4 F-T<br>5 P-T |
| Morgan State University<br>Gallery of Art<br>Hillen and Goldspring Lane<br>Baltimore, MD 21239<br>(301) 444-3030<br>*James Lewis, Director* | 1951 | University | Under $100,000 | None | Owned | NA | NA | 2 F-T |
| Museo de Antropologia, Historia y Arte<br>Universidad de Puerto Rico<br>Recinto de Rio Piedras<br>Apartado 21908, Estacion U.P.R.<br>Rio Piedras, Puerto Rico 00931-1908<br>(809) 751-6485<br>*Annie Santiago de Curet, Director* | 1951 | University | $289,000 | None | Owned | 22,000 | NA | 13 F-T<br>1 P-T |
| El Museo de Arte de Ponce<br>Apartado 1492<br>Ponce, Puerto Rico 00733<br>(809) 848-0505<br>*Luis Martinez, Director* | 1959 | Foundation | $839,000 | Reserve | Owned | 49,500 | 325 | 27 F-T<br>3 P-T |

| Museums | Date Established | Governance | Budget Size | Endowment/Reserve | Status of Facility | Est. Annual Attendance | Membership | Staff Size |
|---|---|---|---|---|---|---|---|---|
| El Museo del Barrio<br>1230 Fifth Avenue<br>New York, NY 10029<br>(212) 831-7272<br>*Petra Barreras, Director* | 1969 | Private | $517,000 | None | Rented | 17,600 | 50 | 6 F-T<br>4 P-T |
| Museum of African-American Art<br>4005 Crenshaw Blvd., 3rd Floor<br>Los Angeles, CA 90008<br>(213) 294-7071<br>*Cheryl Dixon, Director* | 1976 | Private | $310,000 | None | Donated | 9,000 | 400 | 1 F-T<br>5 P-T |
| Museum of African-American Life and Culture<br>P.O. Box 41511<br>Dallas, TX 75241<br>(214) 565-9026<br>*Harry Robinson, Jr., Director* | 1974 | Private | $366,000 | Reserve | Leased | 38,000 | 1,500 | 6 F-T<br>2 P-T |
| Museum of Contemporary Hispanic Art<br>584 Broadway<br>New York, NY 10012<br>(212) 966-6699<br>*Nilda Peraza, Director* | 1956 | Private | $300,000 | None | Leased | 40,000 | 100 | 4 F-T<br>5 P-T |
| Museum of Modern Art of Latin America<br>201-18th Street, NW<br>Washington, DC 20006<br>(202) 458-6016<br>*Belgica Rodriguez, Director* | 1976 | OAS | $310,000 | None | Owned | 22,100 | 270 | 7 F-T<br>2 P-T |

| Museums | Date Established | Governance | Budget Size | Endowment/ Reserve | Status of Facility | Est. Annual Attendance | Membership | Staff Size |
|---|---|---|---|---|---|---|---|---|
| Museum of the National Center of Afro-American Artists<br>300 Walnut Avenue<br>Boston, MA 02119<br>(617) 442-8014<br>*E. Barry Gaither, Director* | 1968 | NCAAA | $275,000 | None | Owned | 14,000 | 600 | 1 F-T<br>10 P-T |
| National Afro-American Museum and Cultural Center<br>Box 578<br>Wilberforce, OH 45384<br>(513) 376-4944<br>*John E. Fleming, Director* | 1972 | Ohio Historical Society | $591,000 | None | Owned | 50,000 | 0 | 17 F-T<br>3 P-T |
| North Carolina Central University Museum of Art<br>1805 Fayetteville Street<br>Durham, NC 27707<br>(919) 683-6211<br>*Norman Pendergraft, Director* | 1971 | University | Under $100,000 | Endowment | Owned | 2,000 | NA | 3 F-T |
| La Plaza de la Raza<br>3540 North Mission Road<br>Los Angeles, CA 90031<br>(213) 223-2475<br>*Gema Sandoval, Exec. Director* | 1972 | Private | $473,000 | Endowment | Leased from city | 10,000 | 500 | NA |

| Museums | Date Established | Governance | Budget Size | Endowment/ Reserve | Status of Facility | Est. Annual Attendance | Membership | Staff Size |
|---|---|---|---|---|---|---|---|---|
| San Francisco African-American Historical and Cultural Society Fort Mason Center, Building C San Francisco, CA 94123 (415) 441-0640 Donneter E. Lane, Board President | 1961 | Private | $95,000 | None | Rented | 50,000 | 50 | 3 F-T 1 P-T |
| South Carolina State College I.P. Stanback Museum/Planetarium Orangeburg, SC 29117 (803) 536-7174 Leo Twiggs, Director | 1980 | University | $93,000 | None | Owned | 20,000 | 60 | 3 F-T |
| Studio Museum in Harlem 144 West 125th Street New York, NY 10027 (212) 864-4500 Kinshasha Conwill, Director | 1967 | Private | $1,863,000 | Reserve | Owned | 70,500 | 2,500 | 42 F-T 1 P-T |

73